DRAWINGS & WATERCOLOURS BY PETER DE WINT

DRAWINGS & WATERCOLOURS BY PETER DE WINT

A loan exhibition inaugurated at the
Fitzwilliam Museum, Cambridge

Selected and catalogued by David Scrase

CAMBRIDGE UNIVERSITY PRESS

CAMBRIDGE

LONDON · NEW YORK · MELBOURNE

Published by the Syndics of the Cambridge University Press
The Pitt Building, Trumpington Street, Cambridge CB2 IRP
Bentley House, 200 Euston Road, London NW1 2DB
32 East 57th Street, New York, NY 10022, USA
296 Beaconsfield Parade, Middle Park, Melbourne 3206, Australia

© Fitzwilliam Museum 1979

First published 1979

Printed in Great Britain at the
University Press, Cambridge

Library of Congress Cataloguing in Publication Data

De Wint, Peter, 1784–1849.
 Drawings and watercolours by Peter De Wint.

 Bibliography: p.
 1. De Wint, Peter, 1784–1849 – Exhibitions.
I. Scrase, David. II. Cambridge. University.
Fitzwilliam Museum. III. Title.
ND1942.D4A4 1979 759.2 79-4652
ISBN 0 521 22745 3 hard covers
ISBN 0 521 29631 3 paperback

CONTENTS

v

PREFACE

The idea to venture a full-scale exhibition of De Wint's achievement in those media of drawing and watercolour wherein he excelled seems a natural one for the Fitzwilliam, the fortunate possessor now of sixty-two of his works on paper. We have been encouraged rather than discouraged in this by the warnings of wiseacres that we should be defeated by the insufficiency of documentation for De Wint's chronology and that we should risk confusing ourselves or others by allowing the efforts of his more talented pupils and imitators to mingle with his personal production. Recognising these common hazards of scholarship and of connoisseurship as extreme in De Wint's case, we thought it preferable to select a variety of the best and best-preserved sheets that we could assemble, and to set out our selection coherently in groups and sequences which may be found suggestive rather than dogmatic, rather than to postpone indefinitely the endeavour, never likely to be a safe one. In this chance to view such a range of material, the interested public may find enjoyment, and specialists an opportunity also to advance or revise their theories.

The collection of De Wint at the Fitzwilliam began only in this century with gifts from a Trinity man, Charles Newton Robinson, in 1910 of one drawing (cat. no. 41), and from Charles Fairfax Murray in 1913 and in 1914 of two drawings (including cat. no. 12). Ten years later the Friends of the Fitzwilliam presented *The Constable's Tower, Dover* (cat. no. 106). However, it was not until August 1927 that a more solid representation of the artist began to develop. In that year J. R. Holliday of St John's College died, having appointed his old and close friend Sydney Cockerell to be his executor; and from the testator's large collection of English watercolours eight fine De Wints were chosen at first for the Fitzwilliam (including cat. nos. 20, 39, 40, 80, 82); and then, in 1931, another two (cat. no. 96). Cockerell, during his time as Director, had the pleasure also of receiving two more De Wint watercolours by bequest from Arthur W. Young of Trinity College (cat. nos. 23, 98); and two of the ten English watercolours given by Mrs Lothian Nicholson in 1943 in memory of her husband were De Wints. Seven years later our holding was to be transformed by the dazzling gift from one of the most discriminating collectors of De Wint, T. W. Bacon; no fewer than twenty-three of the finest examples, which form the core of our contribution to the present exhibition. This transformation inspired further generosity from one of today's leading enthusiasts for De Wint

and for the incessant problems of his oeuvre: R. M. M. Pryor gave us in 1975 through the Friends, in memory of his brother Mark, sometime Senior Tutor of Trinity, sixteen drawings chosen to show the range of the painter's interests and style. Two watercolours have been bought since we received the Fairhaven Fund in 1948: *Caernarvon Castle* (cat. no. 59) in 1966, and in 1977 the magnificent show-piece of De Wint's last years, *On the Dart* (cat. no. 124). The purchase of the latter, for which we had already a superb sketch in the Bacon gift (cat. no. 123), attracted yet another most apt benefaction from Mr Pryor, a less finished and smaller version of the same subject (cat. no. 122). In 1977 also, by way of acquiring further precise documentation, we bid successfully with the Fairhaven Fund for two of the fair copies which were commissioned from De Wint as *modelletti* for the engravings to illustrate Major Light's *Sicilian Scenery* (cat. nos. 27, 28).

Had it been feasible to include loans from beyond the Atlantic we should have wished to borrow from the Yale Center for British Art a splendid watercolour (63/1/178) which is inscribed and dated by De Wint 'Bromley Hill 1812'. This concentrated view of a woodland path manifests an intensity and freedom already developed to the level of that shown in the 1816 sketchbook (cat. nos. 16, 17, 18). Within these islands the response to requests for loans has been heartwarming; and this is appreciated not least in view of the long period during which the lenders, both institutional and private, are ready to deny themselves the company of their possessions, in order that a wider public in five different places may enjoy the fullness of the exhibition. It is particularly gratifying that among the private owners is one, Lord Plymouth, for whose family De Wint painted watercolours at Oakly Park and acted as drawing master; and others who are special champions of De Wint among present-day collectors, Mr Pryor himself, Sir Geoffrey Harmsworth, Mr and Mrs Cyril Fry; as well as several who prefer to remain anonymous. We thank all of them, and no less warmly those who have charge of national, civic and university collections in London, Edinburgh, Dublin, Birmingham, Leeds, Liverpool, Lincoln, Manchester and Oxford.

In assigning to Mr David Scrase the selection and cataloguing of the exhibition, not only was it understood that he would have frequent opportunities of consulting his colleagues here and elsewhere, as well as individual owners of De Wints, but also it was hoped that he might have the advantage of discussion with Mr Hammond Smith, who has long devoted himself to the preparation of a much-needed monograph on the painter. This hope has been gratified; and the preparation of the exhibition and its catalogue have benefited greatly from the generous advice of Mr Smith and of other scholars besides Mr Pryor. Material assistance has come towards the costs of the inaugural showing in the Fitzwilliam from the 1979 Cambridge Festival, to which the exhibition is

the Museum's principal contribution; and, to meet the cost of colour plates in the catalogue, from the Mellon Centre for British Art in London. Without these grants the possibilities would have been sadly curtailed. The Cambridge University Press has undertaken both printing and publishing of the catalogue, fully illustrated in black and white, with some aid from the Arts Council of Great Britain, which has adopted the exhibition and has the organisation of the tour beyond Cambridge. We are grateful indeed to all those responsible for these arrangements in support of our initiative.

Michael Jaffé
Fitzwilliam Museum

INTRODUCTION

For the public it is the simplicity of Peter De Wint's artistic personality and the apparent timelessness of his compositions which give delight, and which account for his steady and increasing popularity. Art-historians have shied from him for lack of specific details about the chronology of his production. Indeed De Wint's early discovery of a method which thoroughly suited his aims as a watercolourist and his reliance upon it throughout his career, those very factors which contribute to the scholar's perplexity, are the basis of his popular reputation. When it comes to analysing his achievement, chronological development does not have such an important part to play.

De Wint was born in Stone in Staffordshire in 1784, the fourth son of Henry De Wint, a doctor of Dutch extraction. The father had come from New York, where his family had settled, to study medicine in England; and he had remained to marry a Scottish girl, against his family's wishes. As a result of this marriage Henry De Wint was disinherited. He intended that his son Peter should follow him as a doctor: but the boy's bent was towards drawing. After initial instruction from a local artist, Mr Rogers, who lived near Stafford, Peter was apprenticed in London in 1802 to the mezzotint engraver and painter, John Raphael Smith; and he stayed with Smith, an associate of Morland and the publisher for whom Turner and Girtin had coloured prints together as boys, until 1806 when he purchased his freedom. That Smith allowed De Wint to break his apprenticeship, at the price of eighteen oil paintings of different sizes to be produced in the course of the next two years, gives an indication of how he rated his pupil's talents. Once free, De Wint set up house with a friend, William Hilton, who had been a fellow-pupil of his with Smith, in Broad Street, Golden Square. There John Varley also lived; and Varley is said to have given De Wint instruction *gratis*. Moreover it was in 1806 that De Wint was received at Adelphi Terrace by Dr Monro. At Monro's he had the opportunity to study Girtin's work at first hand; and it was probably the joint influence of Varley and Girtin which turned his attention to watercolour painting.

Until 1805 painters in watercolour had exhibited alongside painters in oil at the Royal Academy; but the subtler effects of the former were overshadowed by the more flamboyant and immediate impact of the latter. So a group of specialists founded the Society of Painters in Watercolour, more usually known as the Old Water Colour Society, at 20 Lower Brook Street, as a place where their work could be seen free

from a direct comparison with oils. Watercolour painting had been practised with increasing success since the pioneering days of the two Cozens and of Paul Sandby; and the founding of the O.W.C.S. may have helped De Wint in his decision to concentrate on watercolour rather than oil as his principal medium. Other factors which may have played a part were the comparative expense of oil painting, and a realisation that his personal talent was more effective as a watercolourist. Not that De Wint was yet sufficiently mature in his art to be accepted as an exhibitor at the O.W.C.S. His first recorded exhibition was at the Royal Academy in 1807. Then he showed three drawings: two views of Staffordshire and one of the High Tor, Matlock. There he had visited and sketched for the first time the preceding year when travelling from Lincoln, where he had been to stay, also for the first time, with his friend William Hilton. In 1807 Henry De Wint died; and the following year Peter exhibited at the British Institution, and also at the Gallery of Associated Artists in Watercolours, four drawings including *A View of Westminster Hall, Abbey, etc. from the Bridge* (probably cat. no. 2), which shows to what extent he was influenced by Girtin in this early part of his career. By now his chief source of income must have been as a drawing instructor; and the pattern of teaching during the spring and early summer, travelling in the autumn and sketching and painting in the winter, which was to be the rhythm of his later life, was begun. In 1809 he was admitted as a student at the Royal Academy, although he was not admitted to the life classes until 1811. In 1810 he married Harriet Hilton and set up house with her and her brother William in Percy Street. In the same year he was made an Associate of the O.W.C.S. 1811 saw him a Member of the Society, and, for the only time, a father. Until 1815, he continued to exhibit at the Royal Academy, the British Institution and the O.W.C.S.; and in 1814 he also undertook to provide illustrations for engravings, an occupation which he was to continue intermittently until 1841.

From Harriet De Wint's tantalisingly short memoir of her husband, published privately and posthumously, Peter De Wint's character emerges as serious, even difficult and dour. He found great comfort in religion. In money matters he was hard-headed. Armstrong, who drew largely on the memoir and contemporary reminiscences for his book published in 1888, instances: '... a gentleman having bought some drawings, the price was named in guineas: "There are no guineas now, De Wint, so we'll call it pounds." "No you won't! My price, sir, is guineas." "Really, you don't mean to quarrel for the shillings." "Don't I. The shillings are my wife's, and I would quarrel with you for two straws – so take them or leave them."' Most of the anecdotes relating to money show him in a similar light, but he could be generous. Thus he helped finance Keats' visit to Italy in 1821 with a contribution of £10; and on two occasions (1843 and 1846) he accepted from the Royal Dublin Society less than half what he had asked for his drawings,

begging them to consider the balance his contribution to their work. When, in 1818, as a result of the post-war depression, the Watercolour Society collapsed, De Wint continued to work on commissions for printmaking, such as converting Major Light's travelling sketches of Sicily, and Thomas Allason's 'Greek sketches' into compositions suitable to be engraved.

In 1824, De Wint visited Glamorgan and the Lakes for the first time. The following year he was again a member of the revived O.W.C.S. and exhibiting. In 1827 William Hilton was made Keeper of the Royal Academy, moving out of Percy St to Somerset House, and subsequently marrying. Thereupon the De Wints moved to 40 Upper Gower Street (now 113 Gower St), where they remained until the artist's death in 1849. In 1828 De Wint made his only excursion to the Continent, to Normandy: but he was not much impressed with France, and the only fruit of his travels are a few views of Rouen, Caen, Fécamp and Dieppe. As Harriet De Wint only mentions Normandy, the view of Tours in the Tate is probably after someone else's sketch. On his return he ventured into North Wales, a visit which was to prove much more productive and rewarding to his inspiration. The remaining course of De Wint's life was largely uneventful. He continued to teach in London during the spring and early summer, then to spend the rest of the summer at Lincoln or travelling round England and Wales, earning his keep largely as an itinerant drawing master. At various times he stayed with Mr Fawkes at Farnley Hall, the Lonsdales at Lowther, the Honourable Robert Clive at Oakly Park, Mr Ellison at Sudbrook Holme, the Custs at Belton, and the Marquess of Ailesbury. Lord Ailesbury took him for excursions in the North Riding of Yorkshire. He visited Mr Cheney of Badger in Shropshire, the Heathcotes at Connington Castle, Earl Brownlow at Belton House, Mr Sibthorp at Canwick Hall, near Lincoln, Colonel Howard and Mrs Howard at Castle Rising, Levens Hall, Elford and Ashtead, Mr Champernowne at Dartington Hall and several others. Harriet stresses that De Wint was received by all these people as an equal and valued friend. On his travels he made innumerable sketches. These were polished into a more finished state during the winter and exhibited, first in his own studio, at a sort of fashionable preview where everything was for sale, and then by selections at the O.W.C.S. In 1842 he went to Devon for the first time. Probably in 1844, he was persuaded by a dealer, Vokins, to accept him as an intermediary; so that, until his death of bronchitis in 1849, he had no further need to act as his own agent.

The earliest of De Wint's works show the marked influence of Girtin, particularly evident in *Westminster* (cat. no. 2), exhibited in 1808, and in the early townscapes of Lincoln. Girtin's technique of laying in blocks of subdued colour was a lesson which he thoroughly assimilated. Nonetheless he soon developed a more personal style, one in which his

Dutch ancestry appears to play an intuitive part. Looking at the broad vistas of many of his most successful compositions such as *Cliveden on Thames* (cat. no. 14) and the splendid series *On the Trent* (nos. 24, 25) we may be reminded of the compositions of Phillips Koninck and Salomon van Ruysdael. Perhaps De Wint was helped by the solutions which those masters had found to the problems of expressing the profundity of low-lying landscape: he had the opportunity to examine their works at close hand in the houses where he taught. Or his may have been an innate response. Their similarity often is striking.

His works can be surprisingly different in effect. Some are loose and sketchy with marvellous realisation of atmosphere and mood; others are more elaborate. These latter are often cluttered with meticulous detail. The painting of Lincoln Cathedral bought by Mr Ellison in 1841 (cat. no. 81) is a fine example. It has much of the mid-nineteenth-century passion for meticulous finish. The architectural detail and the clustering of genre-like 'staffage' in the foreground are like the Continental scenes of Cotman or Prout. In more typical examples of his finished style, such as the late *On the Dart* (no. 124), of 1848–9, there is less of the slightly unsettling overemphasis on realistic depiction although there is still much effort spent on telling detail. The finish in the small drawings, usually in brown ink, done for engravings, is identical to that of the largest of his finished watercolours. The views of Lincoln Cathedral (cat. nos. 80, 82) and the drawings for 'The Oxford Almanack' (nos. 44, 83) have a precision which is exemplary. The relative lack of crispness in detail of the views in Palermo (nos. 27, 28) is the more surprising. Made for engravings after the sketches of Major Light, they are curiously lacking in definition – perhaps because the original drawings were imprecise.

His oils are less impressive. It is important to remember what Armstrong, quoting a family tradition, says of him. 'About this time [1809] he painted as much in oils as in the lighter medium and would have devoted himself to that metier but for the difficulty he found in selling its results.' Ever practical where money was concerned, De Wint concentrated on watercolour. He did however exhibit an oil, *Vessels in a Fog* (now in the Glasgow Art Gallery), at the Royal Academy as late as 1828, which shows he was still working in that medium, as he continued to do throughout his life. Still, it is strange how much less expressive than his watercolours are many of his oils of whatever period. The brilliant effects of atmospheric conditions which he achieves in watercolour might incline one to hope for something of Constable's genius when painting in oil; but, apart from a few vivacious sketches of water weeds which have a genuine sparkle, his finished oils tend to flatness, an impression partly caused by a general darkening of tone through time. A comparison of the drawing of *Cliveden on Thames* (cat. no. 14), perhaps a preparatory study for the oil *A Woody Landscape* of *c.*

1813, now in the Victoria & Albert Museum, shows this clearly. Another area in which De Wint, unlike his friend Hilton, never achieved much more than competence, was figure drawing. Apart from a swiftly drawn self-portrait, no certain portrait by him survives and the charm of his figure studies lies rather in the fresh use of his medium than in any clear attempt at factual representation. In fact, De Wint, like Constable, has come to be cherished for the loose and limpid sketches from nature which he painted for his own pleasure and as *aides-mémoire* for winter days when something more elaborate would be worked up; the sort of drawing which the poet John Clare describes as 'one of those rough sketches, taken in the fields, that breathe the living freshness of open air and sunshine, where the harmony of earth, air and sky form such a happy union of greens and greys that a flat bit of scenery on a few inches of paper appear so many miles'. Luckily Mrs De Wint appreciated the value of many of these working sketches, and in 1850 she held a sale of 558 of them from De Wint's studio, in 493 lots. She selected only what she considered characteristic; some she destroyed, so as to avoid confusion with those who might try to copy and deceive the public with false De Wints, and the rest were kept by the family. Her sale catalogue was annotated, and the names of the purchasers noted. Furthermore, some of these drawings, perhaps the majority, were numbered and titled in pencil on the verso; and recently, as drawings have been lifted from old mounts, these numberings have been revealed. The lifting has led to the positive identification of several drawings which some have doubted as by De Wint.

 This alone would justify an exhibition of his work. More important, however, is the consideration that whereas Turner, Girtin and Cotman can be said to be familiar to the public, De Wint is not. Sadder still, popular opinion tends to equate his name with a narrow range of his works, harvest scenes, for example, or the highly elaborated drawings which can seem stilted in their finish and which are all too often faded. Published material on De Wint is scant; apart from Armstrong's monograph (1888) and Mrs De Wint's memoirs (1900) little investigatory research has been published. The situation should change when Hammond Smith's new monograph appears. In 1937 the exhibition organised by Sir Geoffrey Harmsworth at Lincoln gave an opportunity to reassess the artist. Oils were included, as well as watercolours and drawings. So the oeuvre was represented as a whole – but no attempt was made to present the works in sequence, or to show working methods. Since then there have been three other considerable exhibitions. In 1966 there was one at Reading, which attempted a chronological assessment, but which was unaware of the dates recently revealed by lifting the drawings from old mounts; and another at Agnew's which concentrated on the more famous and finished works. In 1974 there was a loan exhibition at the Gerald Norman Gallery,

xiv

'Sketches from Nature'. This contained numerous sketches from the collection of De Wint's only grandchild, Miss Tatlock, some of which had not been exhibited, as well as examples from public and other private collections in this country and elsewhere. Among these were drawings from the family collections of De Wint's pupils, which tradition held were by him. Several others came from an album sold at Sothebys in 1972 attributed to 'P. De Wint and other hands'. Many of these have an obvious connection with the Howard family as they comprise depictions of all four of the properties which belonged to the nineteenth-century heiress, Mary Howard, who is known to have been a De Wint pupil. As the drawings are in De Wint's manner it is likely that she was the author of some, and that others are by her fellow-pupils, perhaps with help from himself. In an exhibition of the work of De Wint and his pupils, these would have a place of great interest. Our prime purpose however is to define the master; and we have set out to show a cross-section of all aspects of his work, except the oils, selecting so far as possible autograph examples in good condition. Respecting this criterion, it has also been our intention to show how De Wint built up his sketches from an original drawing or series of drawings done on the spot into a finished work.

The most important surviving examples of how he worked towards his final effects are a series of five drawings which De Wint sold to the Royal Dublin Society in 1846. These, which are now in the National Gallery of Ireland, were painted expressly to show a novice how to produce a watercolour. The titles make their purpose explicit: ' "Blot", such as a young artist is recommended to make before commencing his picture in order to try the quantities of light and shade, as well as the proportions of warm and cool colours' (cat. no. 109); the others form a series, *The Art of Drawing* (nos. 110–13), and De Wint's comment is 'The first of four sketches indicating to the novice the proper method of beginning, carrying on and completing a watercolour drawing'. Luckily, too, the catalogue of the 1850 sale distinguishes between drawings from nature and sketches, which were presumably invented and elaborated from his preliminary drawings on the spot. Sometimes two drawings exist of the same scene from the same viewpoint, the only difference being in tonality (*The Effect of a Passing Shower* (nos. 53, 54), for example). De Wint is known to have gradually darkened the tones of his pictures as he worked toward his final effect; and this also is to be seen in the present exhibition.

In his memoir, Armstrong lists the few pigments which De Wint habitually used: Indian red (specially prepared); vermilion; purple lake; yellow ochre; gamboge; brown pink; burnt sienna; sepia; Prussian blue; indigo (specially prepared). Although he did not often use bodycolour, when he does it is to splendid effect, for example, the *Sketch of a Tree* (cat. no. 85). He usually had two brushes, both large; one with a

fine point, the other 'made well worn'. He saturated with water the old Creswick paper on which he drew, laying a mosaic of rich colour upon it when wet. Highlights were achieved either by straightforward tonal contrast or with punctuation of colour like the brilliant touches of flaming red which have such force in *The Falls of the Machno, Wales* (no. 66), or most frequently by scratching the surface of the paint to reveal the white of the paper below.

The more we look at his sketches and studies of nature, particularly at the loose wash drawings which were so important a part of the posthumous sale, the more De Wint's merit appears to be painterliness. He qualifies as a painter's painter; and it comes as no surprise that he should have been appreciated by Constable, who Mrs De Wint records was a customer. De Wint himself is quoted by his wife as often saying, 'I do so love painting. I am never so happy as when looking at nature. Mine is a beautiful profession.' The works he produced are beautiful, too. They have a quiet intensity, an unflamboyant resolution, and a mastery of tonality and composition which is deeply satisfying.

ACKNOWLEDGEMENTS

The idea for this exhibition was first mooted in Matthew Pryor's house and his enthusiasm and passionate interest in De Wint have been an unfailing encouragement. Hammond Smith generously told me the whereabouts of the series *The Art of Drawing*. He and Mr Pryor both gave considerable advice on the Introduction.

I received much courteous help and hospitality from several private collectors who prefer to remain anonymous. Them I should like to thank.

My particular gratitude is due to Sir Geoffrey Harmsworth, Andrew Hemingway, Mr and Mrs Cyril Fry, Andrew Wylde, and David Fothergill of Harrow School.

Professor Eric Robinson, who owns the copyright, kindly gave permission to quote from the unpublished works of John Clare.

Miss Joanna Drew and Miss Janet Holt of the Arts Council have been untiring in their help; as were the staffs of the Reading Room at the Victoria & Albert Museum, the Witt Library at the Courtauld Institute, and the University Library, Cambridge.

I am especially grateful to the following for their help in the collection for which they have curatorial responsibility:

Mr David Brown, The Ashmolean Museum, University of Oxford

Mr E. V. Forrest, The Williamson Art Gallery and Museum, Birkenhead

Miss Andrea Rose, Birmingham City Museum and Art Gallery

Mr Paul Goldman, The British Museum

Mr John Hutchinson, The National Gallery of Ireland

Mr Alexander Robinson, Leeds City Art Galleries

Mr Richard Wood, The Usher Art Gallery, Lincoln

Mr Marco Livingstone, The Walker Art Gallery, Liverpool

Miss Janice Carpenter, The University of Liverpool Art Gallery

Mr Timothy Clifford and Mr Julian Treuherz, Manchester City Art Galleries

Mr Francis Hawcroft, Miss Angela Bolger and Miss Vivien Knight, The Whitworth Art Gallery, University of Manchester

Mr James Holloway, The National Gallery of Scotland

Mr Martin Butler and Mrs Judy Egerton, The Tate Gallery

Dr Michael Kauffmann, The Victoria & Albert Museum

Much conservation work especially for the exhibition was carried out at the Fitzwilliam Museum by Miss Doreen Lewisohn.

Photographs were supplied by the institutions and by the individual lenders to the exhibition and by the Witt Library. Mr Frank Kenworthy, Chief Photographer at the Fitzwilliam, took the colour plates.

Finally I should like to express my gratitude to my colleagues at the Fitzwilliam for their help and patience, particularly to Professor Jaffé and to Duncan Robinson for much constructive criticism.

CHRONOLOGY OF PETER DE WINT

1784 21 January: born at Stone, Staffordshire, fourth son of Henry De Wint, a doctor of Dutch extraction who had come to England from New York.

1802 7 June: abandoned the study of medicine and took up an apprenticeship with a mezzotint engraver and painter, John Raphael Smith, an associate of Morland, and the publisher for whom Turner and Girtin had coloured prints together in their youth.

1806 17 May: purchased his freedom from Smith at the price of eighteen oil-paintings to be delivered in the course of the next two years.

Visited Lincoln for the first time, with William Hilton. Made his first sketch of the High Tor, Matlock.

Took up residence, with Hilton, in Broad Street, Golden Square, where John Varley also lived.

Received instruction from Varley. Received at Adelphi Terrace by Dr Monro.

1807 Exhibited three drawings at R.A.: two views of Stafford, one of High Tor, Matlock.

Father died. Resides at 40 Windmill St, Rathbone Place.

1808 Exhibited at the Gallery of Associated Artists in Water Colours, four drawings, including *A View of Westminster Hall, Abbey, etc. from the Bridge*. Exhibited at the British Institution.

1809 8 March: admitted as a student at R.A. Resides at 93 Norton St, Fitzroy Square. Exhibited nine drawings at the Gallery of Associated Artists in Water Colours.

1810 12 February: made an Associate of the Old Water Colour Society. Exhibited five drawings with them. 16 June married to Miss Harriet Hilton. Moved into 10 Percy St with his wife and William Hilton.

1811 16 March: admitted to the Life School at the R.A. 10 June: made a Member of the Society of Painters in Watercolour (O.W.C.S.). Birth of only child (later Mrs Tatlock). Exhibited at the R.A. and the O.W.C.S.

1812 Exhibited eleven drawings at O.W.C.S., including *Conisborough Castle, Yorkshire*.

1813–15 Exhibited at the R.A., the O.W.C.S. and the British Institution.

1814–16	Engravings for Cooke's *Picturesque Delineation of the South Coast of England* – including *Undercliff, Isle of Wight*, 1 June 1814 – and Cooke's *Thames Scenery*, 1829.
1816–17	Exhibited at the British Institution.
1818	Exhibited at the O.W.C.S.
1819–20	Exhibited at R.A.
1821	Exhibited at the British Institution; Major Light's *Sicilian Sketches*, published 1823.
1824	Exhibited at the British Institution. Thomas Allason's 'Greek sketches' for Stanhope's *Olympia*. First visit to Glamorgan and the Lakes.
1825	Made a Member of the O.W.C.S. Exhibited there. *Views in the South of France 1825*, after Hughes.
1826	Exhibited at the O.W.C.S. *Literary Souvenir*. Windsor Castle.
1827	Hilton becomes Keeper of R.A. De Wint moves to 40 Upper Gower St (now 113 Gower St). Exhibited O.W.C.S. Drawing for 'The Oxford Almanack'.
1828	Exhibited R.A. and O.W.C.S. Travels to France (Rouen, Caen, Fécamp, Dieppe), and North Wales.
1829	Exhibited O.W.C.S. *View in Normandy* and *Elijah*.
1830	Exhibited O.W.C.S.
1831–4	Exhibited O.W.C.S. First views of North Wales.
1835	Exhibited O.W.C.S. Last visit to North Wales. Drawing for 'The Oxford Almanack.'
1836–41	Exhibited O.W.C.S. Continues annual tours of England.
1839	Drawing for 'The Oxford Almanack'.
1841	Drawing for 'The Oxford Almanack'.
1842	First visit to Devon. Exhibited O.W.C.S. including *Falls of the West Lynn, at Lynmouth*.
1843	Exhibited O.W.C.S. Sale of eight watercolours to the Royal Dublin Society. Sale of *View on the Severn, Shropshire* to John Constable.
1844	Exhibited O.W.C.S. First uses Vokins as a dealer.
1845–9	Exhibited O.W.C.S.
1846	Sale to Royal Dublin Society.
1849	30 June: died in Upper Gower Street.
1850	22–8 May: De Wint sale, Christie's (493 lots total £2364 7s 6d).
1866	Mrs De Wint dies.

BOOKS TO WHICH DE WINT CONTRIBUTED DRAWINGS FOR ENGRAVINGS:

J. Hassall, *Aqua Pictura*, 1812
W. B. Cooke, *Picturesque Delineation of the South Coast of England*, 1849

W. B. Cooke, *Thames Scenery*, 1814–29
George Ormerod, *History of Cheshire*, 1819
Charles Stanhope, *Olympia*, 1824
John Hughes, *Views in the South of France*, 1825
John Clare, *The Shepherd's Calendar*, 1827
Tillotson, *Album of Scottish Scenery*, 1831(?)
George Cooke, *Views in London and its Vicinity*, 1834
Tillotson, *New Waverley Album*, 1834(?)
Van Voorst, *Gray's Elegy*, 1836
J. Jaffray, *Graphic Illustrations to Warwickshire*, 1862

Other engravings were made for:

Windsor Castle, *Literary Souvenir*, 1826
'The Oxford Almanack', *Folly Bridge*, 1827
Gallery of the Society of Painters in Watercolour, *Forest Hall Mountains*,
 1833
Gallery of Modern British Artists, *Goodrich Castle*, 1834(?)
'The Oxford Almanack', *Hythe Bridge and the Tower of Oxford Castle*, 1835
'The Oxford Almanack', *View of Oxford from the Castle Keep*, 1839
'The Oxford Almanack', *View of Iffley by the River*, 1841
The Golynos Oak

EXHIBITIONS

London, 1873, Burlington Fine Arts Club, *Drawings and Sketches by the
 late David E. Cox and the late Peter De Wint*, from the collection of John
 Henderson
London, 1884, Vokins, *Peter De Wint, Centenary Exhibition* (hand list
 deposited in the Victoria & Albert Museum)
London, 1924, Agnew, *Turner, Cox and De Wint*, catalogue included in
 A. P. Oppé's *Turner, Cox and De Wint*, 1925
London, 1937, Palser Gallery, *Peter De Wint and Philip Wilson Steer*,
 foreword by Martin Hardie
Lincoln, 1937, Usher Art Gallery, *Exhibition of the works of Peter De Wint*,
 organised by Geoffrey Harmsworth
Reading, 1966, Museum and Art Gallery, *Peter De Wint*, organised by
 Peter Rhodes, foreword by William Gaunt
London, 1966, Agnew, *Peter De Wint*, organised by Evelyn Joll
Matlock, 1971, Tawney House, *Peter De Wint*
London, 1974, Gerald Norman Gallery, *Sketches from Nature*

ABBREVIATIONS

R.A. – Royal Academy

O.W.C.S. – Old Water Colour Society

Vokins – *Peter De Wint, Centenary Exhibition*, 1884

Armstrong – Sir Walter Armstrong, *Memoir of Peter De Wint*, Macmillan, 1888

Lincoln, 1937 – *Exhibition of the Works of Peter De Wint*, organised by Geoffrey Harmsworth, Usher Art Gallery, Lincoln, 1937

U.G. 1947 – Lincoln, Usher Art Gallery, *Catalogue of the Peter De Wint Collection*, 1947

U.G. 1965 – Lincoln, Usher Art Gallery, *Peter De Wint – A Selection of Drawings and Paintings*, 1965

Reading, 1966 – Museum and Art Gallery, *Peter De Wint*, exhibition organised by Peter Rhodes

Agnew, 1966 – *Peter De Wint*, exhibition organised by Evelyn Joll

U.G. 1972 – Lincoln, Usher Art Gallery, *Peter De Wint*, 1972

SELECT BIBLIOGRAPHY

Sir Walter Armstrong, *Memoir of Peter De Wint*, Macmillan, 1888

J. L. Roget, *History of the Old Water Colour Society*, 2 vols., 1891

G. R. Redgrave, *David Cox and Peter De Wint*, Sampson Low, 1891

L. Binyon, *Catalogue of Drawings by British Artists in the British Museum*, vol. II, 1900

Charles Holmes, 'Peter De Wint', *The Studio*, summer number, 1903

Harriet De Wint, *A short memoir of Peter De Wint and William Hilton R.A.*, published privately, *c.* 1912

Randall Davies, *Peter De Wint*, O.W.C.S. Annual, vol. I, 1924

Old Water Colour Society *Annuals*, passim

A. P. Oppé, *Turner, Cox and De Wint*, 1925

Victoria & Albert Museum, *Catalogue of Water Colour Paintings*, 1927

M. Hardie, 'Peter De Wint', *The Studio*, 1929

Victoria & Albert Museum, *A Picture Book of the Work of Peter De Wint*, 1929

H. Granville Fell, 'Peter De Wint and the English Rural Scene', *The Connoisseur*, vol. 93, p. 219 ff., 1934

Lincoln, Usher Art Gallery, *Catalogue of the Peter De Wint Collection*, 1947

H. E. Rollins (editor), *The Keats Circle*, 1948

Cyril G. E. Bunt, *Peter De Wint and the Peaceful Scene*, 1948

Lincoln, Usher Art Gallery, *Peter De Wint – A Selection of Drawings and Paintings*, 1965

L. Hermann, 'The Timelessness of Peter De Wint', *Country Life*, 3 February 1966

Martin Hardie, *Watercolour Painting in Britain*, vol. II, 1967

Paul Shakeshaft, *Peter De Wint*, unpublished dissertation, Cambridge University, 1971 (copy deposited in the Fitzwilliam Museum)

Lincoln, Usher Art Gallery, *Peter De Wint*, 1972

Andrew Wilton, *British Watercolours, 1750–1850*, Phaidon, 1977

There are numerous references to De Wint in contemporary newspapers and journals, notably the *Athenaeum, Literary Gazette, Examiner, London Magazine* and *London Journal*.

AUTHOR'S NOTE

De Wint's chronology is far from fixed; but there are dated drawings and others which have a *terminus ante quem*, because we know when they were exhibited, engraved, or sold. Working very tentatively from points of this nature, the catalogue has been arranged in a suggested chronological sequence, interrupted by a selection of drawings (cat. nos. 29–43) which have been juxtaposed in an attempt to show the range of De Wint's techniques. It is perhaps salutary to recall the following passage from an obituary notice published in the *Athenaeum* on 7 July 1849: 'He sent his first works to the O.W.C. Exhibition of the year 1810. These were in character and feeling not unlike the works which he contributed to the exhibition still open.'

1 The Quayside, Newport, Isle of Wight

Watercolour
350 × 571 mm (13¾ × 22½ in)
From the collection of the Trustees of the Feeney Charitable Trust
Exhibited: Agnew, 1921

This drawing is consistent in style with De Wint's earliest work. It clearly shows the influence of both Varley and Girtin. De Wint frequented Dr Monro's house from 1806, where he had the opportunity to examine and copy a large number of Girtin's drawings; it was probably there, too, that he met Varley, who for a while gave him free tuition. De Wint was certainly in the Isle of Wight before 1814, when drawings by him were engraved for W. B. Cooke's *Picturesque Delineation of the South Coast of England* (see cat. no. 13).

The City Art Gallery, Birmingham, 87.21

2 Westminster

Watercolour
338 × 803 mm (13 5/16 × 31 5/8 in)
From the collection of Miss H. H. Tatlock
Literature: Armstrong, 1888, pl. 6; *The Studio*, 1903, pl. w. 32; C. Lewis Hind, 1924, *Landscape Painting from Giotto to the Present Day*, vol. ii, reproduced; Victoria & Albert Museum, 1927, *Catalogue of Water Colour Paintings*, p. 168; Victoria & Albert Museum, 1929, *Picture Book of Peter de Wint*, no. 14
Exhibited: ?Associated Artists in Water Colours, 1808, no. 57; Vokins, 1884, no. 82; Lincoln, 1937, no. 100

Miss Tatlock was the artist's grand-daughter. The Old Palace of Westminster is seen from Westminster Bridge; the Abbey's towers are glimpsed in the background and the Thames winds broadly into the distance. Earlier depictions of London from the river, like those of Samuel Scott, are characterised by attention to topographical detail. De Wint clearly subordinates this aspect of his drawing to a distillation of the calm beauty of a summer's day. The nature of the 'soft and silvery' river, as De Wint called it, still wide and slow-flowing, before the Embankment confined it, is brilliantly emphasised by indolent reflections. The critic of the *Repository of Arts* wrote of three paintings De Wint exhibited in 1808, one of which was perhaps this view of Westminster, that they were 'of the first class. Correct observation of nature, fine selection of form, with the greatest truth and simplicity of colour, are characteristics of his style.'

Victoria & Albert Museum, P.61–1921

3 Old Castle, River Scene

Watercolour
260 × 413 mm (10¼ × 16¼ in)
From the collection of James Blair
Exhibited: Manchester, Whitworth Art Gallery, 1921, *Watercolour Drawings and Paintings,* no. 302

Matthew Pryor in a letter to the City Art Gallery stated: 'It is a "fantasy" based on De Wint's 1811 R.A. Exhibited Newark Castle and Bridge which is now in the Ashmolean ...' The influence of both Varley and Girtin is very pronounced, which supports an early date. The handling of the trees and the limpid reflections are characteristic of much of De Wint's art. De Wint continued to paint Newark Castle, and drawings of that title are recorded in Mrs De Wint's account book for 1829, 1838 and 1843.

City Art Gallery, City of Manchester, 1917.137

4 Old Houses on the High Bridge, Lincoln

Watercolour
397 × 518 mm (15⅝ × 20⅜ in)
Literature: The Studio, 1903, pl. w. 33; O.W.C.S. *Annual,* vol. I, 1924, pl. VIII; *Architectural Review,* April 1925, p. 135; Victoria & Albert Museum, 1927, *Catalogue of Water Colour Paintings,* p. 167, fig. 67; Victoria & Albert Museum, 1929, *Picture Book of Peter De Wint,* no. 6
Exhibited: Lincoln, 1937, no. 28; Reading, 1966, no. 2

De Wint first visited Lincoln with his friend William Hilton in 1806. In 1814, four years after he had married Hilton's sister Harriet, he bought a house near the south west corner of Lincoln Castle and he returned there every year until 1848. The city, above all the Cathedral, provided a recurrent stimulus to his imagination. This early drawing shows a scene which can not have failed to appeal to the ideal of the 'picturesque' which was so important a quality in late eighteenth- and early nineteenth-century artistic theory. This is a study for the oil painting in the Victoria & Albert Museum (P.58–1921), which was perhaps the painting exhibited at the R.A. in 1811, no. 377.

Victoria & Albert Museum, 179–1898

5 The Devil's Hole, Lincoln

Watercolour, over traces of pencil with highlights scratched in
387 × 514 mm (15$\frac{1}{4}$ × 20$\frac{1}{4}$ in)
From the collection of L. G. Duke, C.B.E.
Exhibited: Library Concourse, University of East Anglia, 1970, *English Watercolours and Drawings of the 18th and 19th Centuries*

Another, slightly larger, version of this drawing, formerly in the Barlow collection, is now in the National Gallery of Scotland (D.5023/50). The rich juxtaposition of deep-toned colours is a feature of De Wint's earliest drawings. At times, as here, he handles watercolour almost as if it were oil. It is to be remembered that De Wint's master, J. R. Smith, valued his pupil's oils highly, and that De Wint's own earliest ambitions were to oil no less than watercolour. The grandeur of his design shows a daring which, at this period, is matched only by Cotman, Turner and Girtin at their most adventurous.

The collection of Mr and Mrs Cyril Fry

6 A Bridge over a Branch of the Witham, Lincoln

Watercolour, over traces of pencil with highlights scratched in
417 × 516 mm (16$\frac{3}{8}$ × 20$\frac{5}{16}$ in)
From the collection of John Henderson
National Gallery Loan no. 16
Literature: The Studio, 1903, pl. w. 16; Victoria & Albert Museum, 1927, *Catalogue of Water Colour Paintings*, p. 169
Exhibited: Burlington Fine Arts Club, 1873, *David Cox and Peter De Wint*, no. 66

As in the view of *Westminster* (cat. no. 2), the mood is one of calm and peace. The laziness of the summer heat is defined by the man with his back turned towards us, leaning over the bridge. The stillness is pointed by the confidence of the bird in the right-hand corner. The use of the medium is similar in effect to that of *The Devil's Hole* (cat. no. 5). The rich effect of the brick-work on the bridge and the highlights on the fencing are particularly representative of the artist's use of watercolour as if it were oil. The contrast between the finely detailed grasses on the right with the loose handling of the mud around the foot of the bridge on the left, the influence perhaps of Wynants, is characteristic. The figure of the laundress is very similar to that of the girl fetching water in *The Devil's Hole*, and the drawings must be contemporaneous. In 1812 De Wint exhibited a view of an *Old Bridge in Lincoln* at the O.W.C.S. (no. 40), which may relate to this drawing.

Tate Gallery, London, 3492 (transferred 1929)

7 Horses Watering at a Farm, Near Lincoln

Watercolour, over pencil with highlights scratched in
431 × 371 mm (17 × 14⅝ in)

A drawing very similar to this, seen from a slightly closer angle, without the scratched-out birds and ducks, is in another English private collection. It may be a full-scale study for this. The influence of Girtin and Cotman is still paramount, and the drawing shows the characteristics of De Wint's early style.

Private collection in England

8 The Saw-Pit

Grey and brown wash with white highlights, over pencil and black chalk on blue paper
213 × 314 mm (8¾ × 12¾ in)
From the collections of Sir J. C. Robinson; Gerald Robinson; J. R. Holliday
Literature: The Studio, 1903, pl. w. 8
Exhibited: Norwich Castle Museum, 1977, *John Thirtle*, supplementary catalogue, p. 3, 1. 37

A sketch for the watercolour in the Victoria & Albert Museum (cat. no. 9).

Fitzwilliam Museum, Cambridge, 1468

9 A Timber Yard

Watercolour, over traces of pencil with highlights scratched in
381 × 584 mm (15 × 23 in)
From the collection of Mrs J. Carr
Literature: Christian Science Monitor, 20 June 1921; Victoria & Albert Museum, 1927, *Catalogue of Water Colour Paintings*, p. 167; Victoria & Albert Museum, 1929, *Picture Book of Peter De Wint*, no. 13
Exhibited: Reading, 1966, no. 8

As often, the artist has changed his viewpoint between his preliminary idea (cat. no. 8) and his finished drawing. Scratched-out ducks and birds recur throughout his career. The treatment of both the buildings and the reflection of the ducks in the water is closely paralleled by that of *Horses Watering at a Farm* (cat. no. 7).

Victoria & Albert Museum, London, 1934–1900

10 A Saw-Pit

Watercolour, over traces of black chalk with highlights scratched in
273×466 mm ($10\frac{3}{4} \times 18\frac{1}{4}$ in)

The subject relates this drawing to another in the Victoria & Albert
Museum (cat. no. 9), but it is not certain that it was made at the same
time. The house may be Halnaker House in Essex, of which there is a
drawing in the Fitzwilliam Museum (no. 2529), which shows a similar
wood-stack beside the house.

Private collection in England

11 Yorkshire Fells Colour plate I

Watercolour with gum Arabic, over traces of pencil
363×566 mm ($14\frac{5}{16} \times 22\frac{1}{4}$ in)
From the collection of T. W. Bacon
Literature: C. Winter, 1958, *The Fitzwilliam Museum, an Illustrated Survey*,
no. 98
Exhibited: Reading, 1966, no. 61

The influence of Girtin is still much in evidence, particularly in the tonal
contrasts used to create an effect of distance in the background. The
massing of clusters of dark tones to give the impression of trees
ultimately depends on Alexander Cozens, but the looseness of the
washes and the deftness with which De Wint uses his medium are
peculiar to him. Hitherto no artist had used watercolour with such
boldness and imagination; especially telling are the areas of spared paper
around the figures of the cows, which give the animals such splendid
solidity. John Clare probably had this sort of scene in mind when he
wrote: 'The only artist that produces real english scenery in which
british landscapes are seen and felt upon paper with all their poetry and
exillerating expance of beauty about them is De Wint.'

Fitzwilliam Museum, Cambridge, PD.130–1950

12 Undercliff, Isle of Wight

Watercolour with gum Arabic, with highlights scratched in
138×219 mm ($5\frac{1}{2} \times 8\frac{5}{8}$ in)
From the collection of C. Fairfax Murray

This is a drawing for the engraving in W. B. Cooke's *Picturesque
Delineation of the South Coast of England*, published in 1849. De Wint was
one of several artists, including Turner, commissioned to produce
drawings for Cooke's book. Six of his were engraved. The print made

from this watercolour was published in 1814. Cooke comments on this view: 'The View by De Wint represents, with great felicity, the peculiar characteristics of the scenery. It was taken about midway [along the shore] near the very pretty cottage residence of Mrs. Arnold, known as Mirables, the plantations of which, with its terrace-gardens, reach almost to the shore.' The majority of De Wint's drawings for engraving were executed in brown wash. The handling and colouring here show Varley's influence.

Fitzwilliam Museum, Cambridge, 747

13 Freshwater Bay, Isle of Wight

Watercolour, over traces of pencil with highlights scratched in
277×405 mm ($10\frac{7}{8} \times 15\frac{15}{16}$ in)
From the collection of John Slott

Probably drawn on the same visit to the Isle of Wight as cat. no. 12, *c.* 1814. The finish of the drawing can be accounted for if it were produced with a view to Cooke engraving it. Another drawing of the Isle of Wight, connected with the engraved series, is at Harrow School.

National Gallery of Scotland, Edinburgh, D(NG)491

14 Cliveden on Thames

Watercolour with gum Arabic, over traces of pencil with highlights scratched in
298×467 mm ($11\frac{3}{4} \times 18\frac{3}{8}$ in)
From the collections of C. H. Hawkins; T. W. Bacon
Literature: A. B. Bury, *Apollo*, vol. XIX, no. 110, February 1934, pp. 86, 88 repr.; A. Bury, 1950, *Two Centuries of British Watercolour Painting*, pp. 90, 91
Exhibited: R.A., 1934, *British Painting*, no. 886, commemorative catalogue no. 850; Amsterdam, 1936, *Twee Eeuwen Engelse Kunst*, no. 212 repr.; Lincoln, 1937, no. 93; Norwich Castle Museum, 1956, *Watercolours by British Landscape Painters*, no. 32; London, Goldsmith's Hall, 1959, *Treasures of Cambridge*, no. 86; Reading, 1966, no. 47; Reading, 1968, *Paintings of the Thames Valley*, no. 56

The subject appears in two oil paintings by De Wint, both illustrated in *The Studio*, 1903 (w. 2, w. 3): one a sketch formerly in the collection of W. G. Rawlinson, for which this watercolour is probably a study; the

other a finished painting in the Victoria & Albert Museum (261–1872). The latter may be one of the two paintings exhibited at the R.A. in 1813. The treatment of the shadows is particularly reminiscent of Dutch painting, notably the soft, fluid handling of Wynants. There is no certainty that De Wint copied Dutch paintings; but it is improbable that his instinctive appreciation of broad landscape was not supplemented by examining works by Koninck, both Salomon and Jacob Ruisdael, Wynants and others in the houses he frequented: for example, the Koninck sold by Sir Charles Bagot in 1834, when it was exhibited at the British Institute (no. 100), which is now in the National Gallery (no. 4251).

Fitzwilliam Museum, Cambridge, PD.130–1950

15 Lincoln Cathedral from the River

Watercolour
318 × 483 mm (12½ × 19 in)
From the collections of H. Roberts; the late Sir Hickman Bacon
Literature: Iolo Williams, *Early English Watercolour*, 1952, p. 181, pl. CXXXIX
Exhibited: Agnew, 1946, no. 75; Norwich Castle Museum, 1956, no. 34; Agnew, 1966, no. 71

The perspective of the middle distance is not wholly successful, as in the drawings from the 1816 sketchbook (cat. no. 17). At this early stage in his career De Wint frequently treats watercolour as if it were oil. The rich, thick application of paint and the dark harmonies of tone show this very clearly. Lincoln Minster was consecrated in 1092. The bases of the towers were built *c.* 1148; the upper parts date from 1365.

16 Cows on a Riverbank

Watercolour
141 × 275 mm (5⅝ × 10⅞ in)
From the collections of Dr Monro; Mr Tiffin

This is a page from a sketchbook of 1816. On the flyleaf of the book was inscribed: 'P De Wint / Sketches (partly) made at Lincoln in 1816 / sold to Dr. Monro at the [?] Drawing / bought by Mr Tiffin for £12.12.0 . . . / At Christies'.

Private collection in England

17 Sunshine after Rain

Watercolour
146 × 256 mm ($5\frac{3}{4}$ × 10 in)
From the collections of Dr Monro; Mr Tiffin

A page from the 1816 sketchbook (see cat. no. 16). A sketch for the watercolour in the Usher Gallery, Lincoln, no. 1892, *A Gleam of Sunshine after Rain*. The thick, mealy paper has been used to marvellous effect. In the right-hand corner the brush has been dragged across the surface leaving areas of paper uncovered by paint which add to the sensation of the surface of the water being broken by ripples, which fragment the reflections of the trees. The finished drawing has a group of burdock leaves in the foreground, clearly showing Dutch influence, and another figure on the right, which is reflected in the water which is also 'staffed' with water weeds.

Private collection in England

18 Boats Tied Up

Watercolour
148 × 289 mm ($5\frac{7}{8}$ × $11\frac{3}{8}$ in)
From the collections of Dr Monro; Mr Tiffin

A page from the 1816 sketchbook (see cat. no. 16). Several other pages from this book were on the London market in 1977.

Private collection in England

19 Old Houses

Watercolour, over traces of pencil
230 × 216 mm ($9\frac{1}{16}$ × $8\frac{1}{2}$ in)

A study of old houses, probably in Lincoln. This study is less concerned with accuracy of architectural definition than with the mood evoked by the ageing of the fabric.

Lincolnshire Museums: Usher Gallery, Lincoln, UG.75/58

20 A Ruined House at Lincoln

Watercolour with gum Arabic, over traces of pencil
331 × 469 mm (13$\frac{1}{8}$ × 18$\frac{1}{2}$ in)
From the collections of Miss H. H. Tatlock; J. R. Holliday
Inscribed, *verso*, in pencil: 'F / £8–8.s / at Lincoln / Mrs De Wint'
Exhibited: Lincoln, 1937, no. 141; Reading, 1966, no. 5, repr.

In Cooke's *River Thames* of 1835 there is a description of old houses near
Eton, which summarises the nineteenth century's understanding and
passion for the picturesque. It constitutes an eloquent commentary on
this drawing as well. 'The picturesque is a quality, in some objects,
which renders them fit and proper to be imitated in painting. Its vital
principle is to be found in that spontaneous and seemingly fantastical
variety, which nature never fails to produce when left to herself; she is
its fostering parent, and art its mortal foe. Ruggedness, roughness and
abruptness, are to the picturesque, what softness, smoothness and
undulating lines are to beauty. These are the outward and visible signs:
its softer graces are, variety, intricacy, and richness of colour, of light
and shade, and form. The sublime affects us with awe and terror; the
beautiful with admiration and repose; the picturesque with an animated
enlivening irritation, which arouses curiosity.

'It is obvious to which of these classes the object before us belongs.
We must first imagine them newly built; the tiles which cover them
would have been of a fiery red colour, and the walls white as snow. In
that state to the picturesque eye, they would have been wholly
uninteresting; but nature, in process of time, makes everything her own.
In resolving these materials into their first principles she has spread a
many coloured mantle over them; the once white walls are weather-
stained; here are cool grey tints, there are warm purples; in one part a
subdued murky green, in another a red sandy hue; here the white wash
has peeled off and left the bare timbers; these are seen in their rough
hewn forms; the red tiles are in some places covered with a bright green
moss, in others with a deeper colour; some are misplaced, others
broken; the mortar in the chimnies has given way, making rugged lines
... then we perceive a variety of light and shade and reflection ...'

De Wint's continuing fascination with picturesque scenes is evinced
by his watercolour of 1847 of a *Cottage at Aldbury*, now in the Usher
Gallery (UG.906).

Fitzwilliam Museum, Cambridge, 1463

21 Pottergate, Lincoln

Watercolour
290 × 397 mm ($11\frac{7}{16}$ × $15\frac{5}{8}$ in)
From the collection of Miss H. H. Tatlock
Literature: *The Studio*, 1903, pl. w. 24; *The Studio*, 1929, 'Peter De Wint';
Victoria & Albert Museum, 1927, *Catalogue of Water Colour Paintings*, p.
167; Victoria & Albert Museum, 1929, *Picture Book of Peter De Wint*,
no. 18
Exhibited: Lincoln, 1937, no. 135

The influence of Girtin is evident, and the drawing is probably early.
However, the draughtsmanship is more secure than in the *Old Houses on
the High Bridge, Lincoln* (cat. no. 4) and the drawing is likely to be a little
later than that. The Pottergate is of fourteenth-century origin.

Victoria & Albert Museum, London, P.59–1921

22 Crewe Hall

Pencil and watercolour
176 × 277 mm (7 × $10\frac{3}{4}$ in)
From the collection of R. Jackson
Literature: *Connoisseur*, vol. 93, p. 219

De Wint drew Crewe Hall for Ormerod's *History of Cheshire*, published
in 1819, and no. 22 is a preliminary drawing for that engraving. It shows
that great attention to detail which Granville Fell deplored in his article
in *The Connoisseur*, and which is also evident in the drawing of Crowland
Abbey (cat. no. 56). There is a more finished watercolour of Crewe Hall
in a private collection in England. Crewe Hall was built by Sir Randolf
Crew from designs by Inigo Jones between 1615 and 1636. It was
restored in 1837, but was almost totally destroyed by fire in 1866, after
which it was rebuilt by Barry.

Trustees of the British Museum, London, 1888–7–15–11

23 A View in Lincolnshire

Watercolour with traces of gum Arabic, over pencil
361 × 562 mm ($14\frac{1}{4}$ × $22\frac{1}{8}$ in)
From the collection of Arthur W. Young

De Wint has dragged his loaded brush across the paper to give a most
realistic limpidity to the water which looks still wet to the touch. The
slightly unfocused effect gives the impression of a heat haze.

Fitzwilliam Museum, Cambridge, 1793

24 On the Trent near Burton Joyce, Nottinghamshire

Watercolour, over pencil with highlights scratched in
350×562 mm ($13\frac{3}{4} \times 22\frac{1}{8}$ in)
Exhibited: Agnew, 1954, *Whitworth Watercolours*, no. 79; Reading, 1966, no. 50; Agnew, 1966, no. 25

The viewpoint is particularly effective for displaying the winding of the Trent. The islet in the middle ground bridges the gap between the boat which dominates the foreground and the distant church which acts as a caesura in the background. A comparison of this drawing with the *Yorkshire Fells* (cat. no. 11) shows how much more assured the artist has become in his handling of the niceties of perspective. According to Harriet De Wint, her husband, who was partial to river scenery and studied much on the borders of the Trent, described the river as 'bright and sparkling'.

Whitworth Art Gallery, University of Manchester, D.31–1887, presented by the Guarantors of the Royal Jubilee Exhibition, 1887

25 On the Trent

Watercolour, over pencil
317×444 mm ($12\frac{1}{2} \times 17\frac{1}{2}$ in)
From the collection of Lady Broadhurst

Girtin's influence, still very evident, is complemented by the artist's response to low-lying landscapes in the Dutch manner.

Whitworth Art Gallery, University of Manchester, D.31–1887

26 A View at Lincoln

Watercolour, over traces of pencil
240×332 mm ($9\frac{7}{16} \times 13\frac{1}{8}$ in)
From the collections of Mrs Worthington; R.M.M. Pryor, M.B.E., T.D., M.A.

The sweep of the landscape and its calm, relaxed beauty have much in common with the mood of seventeenth-century Dutch landscapes.

Lincolnshire Museums: Usher Gallery, Lincoln, UG.72/218

27 Palermo from the Gardens of the Convent of Santa Maria di Jesù

Brown wash, over slight traces of pencil
132 × 204 mm ($5\frac{3}{16}$ × 8 in)

With its companion piece (cat. no. 28), this is one of the sixty-two drawings done after original drawings by Major Light for W. B. Cooke's *Sicilian Scenery*. The drawing was engraved by J. Meddiman and printed by McQueen and Company; it was published by Rodwell and Martin on 1 April 1823. (The prints after this and no. 28 are shown alongside.) From 1812 the market for watercolours dropped substantially, presumably because of the economic crisis caused by the Napoleonic Wars. Consequently De Wint, along with many other artists such as Turner, Cox and Cotman, was compelled to undertake drawings for engravings in order to help support his wife, daughter and ageing mother. De Wint never visited Italy, but, as in his drawings for Stanhope's *Olympia* of 1824, he reworked the drawings made on the spot by an amateur draughtsman.

Fitzwilliam Museum, Cambridge, PD.6–1977

28 View near Palermo

Brown wash, over slight traces of pencil with highlights scratched in
106 × 217 mm ($4\frac{3}{16}$ × $8\frac{9}{16}$ in)

After the drawing by Major Light for *Sicilian Scenery*. The engraving of the drawing by J. Meddiman was published on 1 July 1821. Four other drawings from the same series were sold at Christie's, 1 March 1977.

Fitzwilliam Museum, Cambridge, PD.7–1977

29 Sketch of a Tree and the Hull of a Boat at Mooring

Colour plate II

Watercolour
253 × 216 mm (10 × 8½ in)
From the collection of T. W. Bacon
Exhibited: R.A., 1934, *British Painting*, no. 122, commemorative catalogue no. 856; Lincoln, 1937, no. 180

Though the drawing was previously titled *Sketch of a Tree and Shed*, the shape on the right is clearly that of one of the covered barges which plied the Thames and other waterways of England in the early nineteenth century. The sketch has a freedom of design combined with a looseness of treatment which has parallels with the Zen-inspired art of the Far East.

Fitzwilliam Museum, Cambridge, PD.137–1950

30 Study of Weeds in Water

Watercolour, with highlights scratched in
261 × 331 mm (10¼ × 13 in)
From the collection of Sir Edward Marsh, C.B., C.M.G., C.V.O., presented through the N.A.–C.F.
Exhibited: Lincoln, 1937, no. 217

Brilliance of colouring is matched by subtle placing on the paper. Like the *Sketch of a Tree and the Hull of a Boat at Mooring* (cat. no. 29), this has a simplicity which is almost oriental in effect. There is a small group of other watercolour sketches of weeds, notably *Dockleaves* in the Usher Gallery (UG.1960); and there are at least four small oil sketches of similar studies, all exhibited at both the 1884 and the 1937 exhibitions, and now in private collections in England, each of which shows De Wint's manner in oil at its very best.

National Gallery of Scotland, Edinburgh, D.4700

31 Lobster Pots

Watercolour with gum Arabic, over traces of pencil
234 × 297 mm (9¼ × 11¾ in)
From the collection of T. W. Bacon
Exhibited: Louisville, Kentucky, 1977, *British Watercolours: A Golden Age, 1750–1850*, no. 85
Verso: in brown wash, a lobster pot

Lobster pots appear as staffage in De Wint's paintings throughout his career. Similar ones to these, without the anchor, are to be seen in his engraving of Ventnor, Isle of Wight, in Cooke's *Delineation of South East England* of *c.* 1816; in the view of Walton-on-Thames of 1848 (cat. no. 117) there is one in the foreground.

Fitzwilliam Museum, Cambridge, PD.140–1950

32 Hawk-Bit, Oxe-Eye Daisy and Hedge-Parsley

Watercolour
541 × 190 mm (21 5/16 × 7½ in)
From the collections of Miss H. H. Tatlock; Miss G. M. Bostock
Literature: U.G. 1947, pl. xxi, no. 30; U.G. 1965, pp. 28, 29; U.G. 1972, p. 9
Exhibited: Lincoln, 1937, 'Personalia'

Two sheets from a sketchbook of twenty-nine leaves, which are mainly botanical studies. This and the other studies (cat. nos. 30, 33) indicate De Wint's ability to combine accuracy of detail with strong compositional sense and feeling for design. Miss Bostock was Miss Tatlock's companion. The sketchbook was acquired by the Usher Gallery with the aid of the N.A.–C.F.

Lincolnshire Museums: Usher Gallery, Lincoln, UG.873, pp. 8 & 9

33 Anemones

Watercolour, over traces of pencil
273 × 190 mm (10¾ × 7½ in)
From the collections of Miss H. H. Tatlock; Miss G. M. Bostock
Literature: U.G. 1947, pl. xxi, no. 30; U.G. 1965, pp. 28, 29; U.G. 1972, p. 9
Exhibited: Lincoln, 1937, 'Personalia'

Another sheet from the sketchbook mostly devoted to botanical studies (see cat. no. 32).

Lincolnshire Museums: Usher Gallery, Lincoln, UG.873, p. 21

34 Interior with a Dog

Watercolour
343 × 457 mm ($13\frac{1}{2}$ × 18 in)
From the collections of Miss H. H. Tatlock; Miss G. M. Bostock
Exhibited: Lincoln, 1937, no. 19; Reading, 1966, no. 96

The interior is of 10 Percy Street, where De Wint lived until 1827.

The collection of Sir Geoffrey Harmsworth

35 Still-Life, 1847

Watercolour, over traces of pencil
222 × 178 mm ($8\frac{3}{4}$ × 7 in)
Dated, upper left, 1847
Literature: Martin Hardie, *Watercolour Painting in Britain*, vol. II, pl. 206
Exhibited: Library Concourse, University of East Anglia, 1970, *English Watercolours and Drawings of the 18th and 19th Centuries*

De Wint was fond of posing the problem of still-life. Armstrong describes the method as it was handed down to him by J. M. Heathcote, one of De Wint's best pupils: 'He would take any convenient objects he could find in the room and set them in a group on the table, with a towel or other white cloth carelessly thrown against them. These he required to be carefully imitated.' Several of these have survived; some, as this and the examples in the National Gallery of Ireland, by De Wint himself. Others are clearly by his pupils; and there is a group where the juxtaposition of competent handling with maladroit modelling implies the collaboration of master and pupil. The enjoyment De Wint's pupils derived from their work was echoed by D. H. Lawrence: 'To copy a nice De Wint is the most soothing thing I can do.'

The collection of Mr and Mrs Cyril Fry

36 Self-Portrait

Pencil
115 × 145 mm ($4\frac{1}{2}$ × $5\frac{11}{16}$ in)
From the collection of Miss H. H. Tatlock
Literature: U.G. 1965, p. 31; U.G. 1972, p. 16
Exhibited: Reading, 1966, no. 89

There is one other portrait of De Wint, a miniature by William Hilton in the Usher Gallery. This drawing shows the artist in his early middle age.

Lincolnshire Museums: Usher Gallery, Lincoln, U.G.1681

37 Near Epping

Pen and brown ink
71 × 209 mm ($2\frac{13}{16}$ × $8\frac{1}{4}$ in)
From the collections of Mrs De Wint; Mrs Tatlock; Miss H. H. Tatlock;
Miss G. M. Bostock; Sir Geoffrey Harmsworth; R. M. M. Pryor,
M.B.E., T.D., M.A., given by him through the Friends of the
Fitzwilliam Museum in memory of his brother, Dr Mark Pryor of
Trinity College, Cambridge

A preliminary study for *Near Epping Forest*, formerly in the collection of
James Orrock (illustrated in *The Studio*, 1903, pl. w. 28).

Fitzwilliam Museum, Cambridge, PD.85–1975

38 A Distant View of Ullswater

Pen and brown ink, with grey wash
106 × 180 mm ($4\frac{3}{16}$ × $7\frac{1}{16}$ in); 115 × 190 mm ($4\frac{1}{2}$ × $7\frac{1}{2}$ in)
From the collection of Mrs A. G. Dawes

Two sheets from a sketchbook, inscribed 'a Distant view of Ullswater'.
Perhaps the first idea for the watercolour of that title exhibited at the
O.W.C.S. in 1825, no. 14. Sketchbooks by De Wint, often annotated, are
in the Victoria & Albert Museum and in the British Museum. They
contain a number of quick sketches like this in which De Wint could
record his immediate impressions of a view. The application of the wash
gives an immediate sense of volume and distance.

Lincolnshire Museums: Usher Gallery, Lincoln, UG.76/12 a & b

39 The Timber Waggon

Pencil, with black and white chalk, on blue coloured paper
235 × 363 mm ($9\frac{1}{4}$ × $14\frac{1}{4}$ in)
From the collection of J. R. Holliday

Many drawings in this combination of media appear in De Wint's
sketchbooks.

Fitzwilliam Museum, Cambridge, 1470

40　Returning from the Market, Beverley, Yorkshire

Black and white chalk, with traces of pencil, on brown paper
180 × 532 mm ($7\frac{1}{16}$ × 21 in)
From the collection of J. R. Holliday

Drawn on two sheets, joined in the middle, this is probably from the same sketchbook as B.1977.14.5250 in the Yale Center for British Art, which is inscribed and dated 'At Cheddington / August 1847'. These drawings exemplify De Wint's penchant for long and broad-sweeping vistas.

Fitzwilliam Museum, Cambridge, 1469

41　The Devil's Tower, Norwich

Black chalk, with white chalk highlights, on grey paper
327 × 528 mm ($12\frac{7}{8}$ × $20\frac{13}{16}$ in)
From the collection of C. Newton Robinson
Exhibited: Norwich Castle Museum, 1977, *John Thirtle*, supplementary catalogue, p. 3, no. L.37

The Devil's Tower, which appears to have received that title in the nineteenth century, is part of the medieval fortifications of Norwich. A popular theme with Norwich School artists – the Cotmans, Stark and Thomas Lound all drew it – there are three drawings of it by John Thirtle in the Castle Museum's collection. Two of these are taken from a very similar viewpoint to De Wint's, and on the grounds of this the attribution has not always been accepted. However, the handling of detail, such as the boats and cows, the contrast of black and white chalk in the sky and the treatment of the birds, are all very characteristic.

Fitzwilliam Museum, Cambridge, 3412

42　A View of Snowdon

Black chalk, with highlights in white bodycolour and grey wash, on grey paper
273 × 375 mm ($10\frac{3}{4}$ × $14\frac{3}{4}$ in)
Inscribed, *verso*, in pencil: Snowdon from the road between Bedd-gelert and Capel Curig'

De Wint first visited North Wales in 1829 or 1830, and returned on several occasions before his last trip in 1835. He rarely used bodycolour,

probably because its effect is less subtle than watercolour. Here it gives a piquancy which sharpens the romantic grandeur of the scene.

Private collection in England

43 Sketch of a Panoramic Landscape with a Donkey

Brush and brown ink, with brown wash and watercolour
300 × 474 mm (11$\frac{7}{8}$ × 18$\frac{3}{4}$ in)
Literature : L. Binyon, 1900, *Catalogue of Drawings by British Artists*, vol. II, p. 33; *Connoisseur*, vol. 93, p. 219, H. Granville Fell, 'Peter De Wint and the English Rural Scene', illustrated

It would appear from this drawing that De Wint had been looking at the work of Claude Lorrain. The tonal contrast, with its particularly effective dark tones, bears comparison also with Alexander Cozens' 'blot' drawings and it is worth remembering that Ruskin had dismissed De Wint with the epithet 'blottesque'.

Trustees of the British Museum, London, 1892–7–14–447

44 Folly Bridge from the South East, 1827

Brown wash, over pencil
197 × 365 mm ($7\frac{3}{4}$ × $14\frac{3}{8}$ in)
On loan to the Ashmolean Museum, Oxford
Exhibited: Lincoln, 1937, no. 186

De Wint was commissioned to do several drawings for the Clarendon Press; this was engraved for 'The Oxford Almanack' of 1827.

The Delegates of the Clarendon Press, Oxford

45 Lincoln Cathedral from the River

Watercolour, with highlights scratched in
495 × 698 mm ($19\frac{1}{2}$ × $27\frac{1}{2}$ in)
From the collection of E. E. Cook, bequeathed through the N.A.–C.F.
Exhibited: Agnew, 1966, no. 110; Matlock, 1971, Tawney House – *Peter De Wint*, no. 9

Although De Wint lived through a period of great upheaval and change, his landscapes, like Jane Austen's novels, show little or no sign of either the Napoleonic Wars or the Industrial Revolution. He seems consciously to have chosen to depict scenes of calm.

Lincolnshire Museums: Usher Gallery, Lincoln, UG.2270

46 Cookham on Thames

Watercolour, with highlights scratched in
467 × 747 mm ($18\frac{3}{8}$ × $29\frac{3}{8}$ in)
From the collections of Arthur Sanderson; Beecham; Sir Sydney Jones
Literature: The Studio, 1903, pl. w. 11; *University of Liverpool, Art Collections: A Selection*, 1977, no. 222
Exhibited: Agnew, 1924, *Turner, Cox and De Wint*, no. 51; R.A., 1934, *British Art*, 763; Lincoln, 1937, no. 32; Palser Gallery, 1937, *Peter De Wint and Philip Wilson Steer*, no. 30

De Wint was involved with W. B. Cooke's *Thames Scenery (Views on the Thames)* between 1814 and 1829, and he produced thirteen drawings for it. This is not directly associated with any of these, but may have been produced at much the same time. The Thames was a constant source of

inspiration to De Wint and several paintings of it are listed by Mrs De Wint as sold in the 1830s.

The University of Liverpool, 222

47 Lancaster

Watercolour, over black chalk and pencil
268 × 457 mm ($10\frac{9}{16}$ × 18 in)
From the collection of the Rev. C. J. Sale

De Wint exhibited three views of Lancaster at the O.W.C.S., one in 1826, another in 1828 and the third in 1834. The elemental way in which he has blocked out the buildings in the foreground and middle distance is a trick first seen in the *Old Houses on the High Bridge, Lincoln* (cat. no. 4); it recurs in both the *Sketch of a Landscape with a Donkey* (cat. no. 43) and *Caerphilly Castle* (cat. no. 48).

Trustees of the British Museum, London, 1915–3–13–26

48 Caerphilly Castle Colour plate III

Watercolour, over traces of pencil
264 × 469 mm ($10\frac{3}{8}$ × $18\frac{7}{16}$ in)
Inscribed, *verso*, in pencil: 'Caerphilly Castle – Sunset'
From the collection of T. W. Bacon
Exhibited: Amsterdam, Stedelyk Museum, 1936, *Twee Eeuwen Engelse Kunst*, p. 84, no. 213; Norwich Castle Museum, 1956, *Exhibition of Watercolours by British Landscape Painters*, no. 35

De Wint exhibited a drawing of Caerphilly Castle at the O.W.C.S. in 1829 (no. 211), the same year that he first visited North Wales. His initial reluctance to go to Wales, a country which inspired many of his contemporaries such as David Cox to produce their best work, is recounted by Harriet De Wint. 'From having early in life seen very bad drawings of Wales he had an idea he should not like the scenery and consequently did not go there until 1829 or 1830, but, seeing the country himself, he declared it was the land for a painter. The sublime and beautiful were so blended and diversified, that every step afforded a subject for a picture.' The old name for the castle according to Harris ('Dissertation on the Welsh Roman Antiquities', *Archaeologia*, vol. II, p. 2) was the Blue Castle. The steely tones of De Wint's drawing endorse this suggestion.

Fitzwilliam Museum, Cambridge, PD.118–1950

49 A Seascape

Watercolour
134 × 324 mm (5¼ × 12¾ in)
Inscribed, *verso*: 'Sketch by Mr De Wint given to me by him, Henry Holland'
From the collections of Henry Holland; Sir William Dyce Ackland
Exhibited: Library Concourse, University of East Anglia, 1970, *English Watercolours and Drawings of the 18th and 19th Centuries*

The inscription appears genuine. This sketch is the sort of scrap of nothing which John Clare strove in vain to persuade De Wint to give him.

The collection of Mr and Mrs Cyril Fry

50 Windmill and Boatmen

Watercolour, over traces of pencil
260 × 241 mm (10¼ × 9½ in)
From the collections of Miss H. H. Tatlock; Sir Geoffrey Harmsworth
Exhibited: Lincoln, 1937, no. 40

This quick and brilliant study has the characteristics of work done out of doors.

Private collection in England

51 Study of a Girl and Boy with a Bucket

Watercolour, over traces of pencil
216 × 190 mm (8½ × 7½ in)
Literature: Martin Hardie, *Watercolour Painting in Britain*, vol. II, pl. 205
Exhibited: Library Concourse, University of East Anglia, 1970, *English Watercolours and Drawings of the 18th and 19th Centuries*

De Wint is not particularly associated with figure drawing; and in his full-scale watercolours figures are usually incidental to the landscape. Nonetheless several such studies survive, many of them of considerable charm.

The collection of Mr and Mrs Cyril Fry

52 A Street in Dieppe

Watercolour, over traces of pencil, on paper stamped 'Improved / Drawn Paper / Rough / Thomas Creswick'
195 × 270 mm ($7\frac{3}{4}$ × $10\frac{5}{8}$ in)
Exhibited: Anthony Reed, 1976, *David Cox*, no. 72

De Wint made his only trip to the Continent in 1828, when he visited Normandy. A few large-scale watercolours, such as that of *Dieppe Castle from the Beach*, now in the Usher Gallery, Lincoln (UG.2248), and several studies like this were the fruit of this journey. The scene was identified by Canon Atkins, Vicar of St George's, Hanover Square, as a view from the Old City Wall, looking down the Rue de la Barre to the church of St Jacques. Rough Creswick paper was De Wint's favourite support, presumably because its thick grainy surface added texture to his use of watercolour.

Private collection in England

53 The Rainbow

Watercolour, over traces of pencil
321 × 477 mm ($12\frac{5}{8}$ × $18\frac{3}{4}$ in)
From the collections of W. W. Sampson; Harold Bompass

This and cat. no. 54 show two stages in De Wint's manner of working towards a finished drawing. The full process can be followed in the drawings done for the Royal Dublin Society in 1846 (cat. nos. 110–13). On the old mount this drawing was titled 'Near Harrow or the Rainbow': but it has not been possible to identify the view.

Private collection in England

54 The Effect of a Passing Shower

Watercolour with gum Arabic
317 × 494 mm ($12\frac{1}{2}$ × $19\frac{1}{2}$ in)
Inscribed, *verso*, in pencil: 'Effect of a Passing Shower' and '243'
From the De Wint sale, 1850, lot no. 243, sold to Jury. From the collections of Gibson-Carmichael; Orrock; T. W. Bacon
Literature: *The Studio*, 1903, pl. w. 21
Exhibited: R.A., 1934, *British Art*, no. 880 (commemorative catalogue, no. 846, illustrated pl. clxxxii); Lincoln, 1937, no. 108; Reading, 1966, no. 70

The scene was identified tentatively as Leicestershire in the 1934 catalogue. In 1937 it was called 'Landscape with Rainbow, Caerphilly Castle', which, as Peter Rhodes pointed out, is inaccurate. Harrow has also been proposed (see cat. no. 53). De Wint exhibited two drawings of rainbows at the O.W.C.S. in 1828 (no. 87) and 1831 (no. 93), and this may be related to one of them; although in terms of stylistic analysis, the drawings are more in keeping with his later style. They may relate to the *Stormy Effect on the Cross Fells, Cumberland* of 1840. The description of the reviewer of the *Athenaeum* in 1847 of the *View in Epping Forest* well matches the effect that De Wint has realised here: '... the effect of a passing storm and the bursting forth of light are given with great truth'.

Fitzwilliam Museum, Cambridge, PD.132–1950

55 Penrhyn Castle

Watercolour, with bodycolour and black and white chalks, on grey paper
370 × 542 mm (14$\frac{9}{16}$ × 20$\frac{3}{8}$ in)
From the collection of Miss H. H. Tatlock

In 1832 De Wint exhibited a view of *Penrhyn Castle with a Distant View of Puffin Island* (O.W.C.S. no. 103); and in Mrs De Wint's account books a *Distant View of Penrhyn Castle* was sold. This drawing, which remained in the family's collection until it was presented to the British Museum by De Wint's grand-daughter, may have been drawn on the same occasion. The wildness of the situation has evoked a particularly romantic response from De Wint with something of the sublimity of Turner's Alpine scenes.

Trustees of the British Museum, London, 1913–5–24–6

56 Crowland Abbey, Lincolnshire

Pencil and wash, with traces of white chalk, on brown paper
254 × 356 mm (10 × 14 in)
From the collections of Miss H. H. Tatlock; Miss G. M. Bostock
Exhibited: Lincoln, 1937, no. 163

In 1833 (no. 89) and in 1835 (no. 20) De Wint exhibited views of Crowland Abbey. This architectural study is connected with the second of these. It is unusual for De Wint in its explicit detail, although this is much less marked than a similar study would have been by his contemporary Prout. Despite the attention to accuracy of particular forms, it is clear that what really interests De Wint is the general

appearance and a sense of the building's mass. A monastery was founded at Crowland in 716 by King Aethelbald in honour of St Guthlac of Mercia. This was burnt by Danish invaders in 870 and again in 1091. The Norman Abbey was erected in 1113.

The collection of Sir Geoffrey Harmsworth

57 Torksey Castle on the Trent, Lincolnshire

Watercolour, over traces of pencil
298 × 464 mm (11¾ × 18¼ in)
Literature: U.G. 1972, p. 15, repr.
Exhibited: London, The Alpine Club, 1971, no. 11

A sketch probably for this drawing is also in the Usher Gallery (UG.852); and another view is in the Victoria & Albert Museum (3050–1876), perhaps the drawing exhibited at the O.W.C.S. in 1835 (no. 31). De Wint's handling shows a remarkable freedom and his colour has an audacity which few of his contemporaries would dare to emulate when drawing an English landscape. Torksey Castle, founded by King John, was demolished in the Civil Wars.

Lincolnshire Museums: Usher Gallery, Lincoln, purchased by the Heslam Trust, UG.71/88

58 A Ruined Abbey

Watercolour, over traces of pencil
280 × 426 mm (11 × 16¾ in)
From the collections of M. J. Hardcastle; H. B. Figgis
Literature: A. P. Oppé, 1925, *Turner, Cox and De Wint*, pl. xxxii
Exhibited: Agnew, 1924, *Turner, Cox and De Wint*, no. 44; R.A., 1934, *British Art*, no. 882; Vienna, 1935, no. 113; Prague, 1935, no. 115; Bucharest, 1936, no. 95; Lincoln, 1937, no. 136; Paris, 1938; Leeds, 1946; Agnew, 1954, *Whitworth Watercolours*, no. 81; Wakefield, 1956, no. 87; Agnew, 1966, no. 44

A highly romantic interpretation of a ruined abbey, formerly thought to be Kirkstall, but more likely Llanthony in Monmouth. The lack of human figures or detail in the foreground increases the sensation of desolation and tranquillity.

Whitworth Art Gallery, University of Manchester, D.9–1945

59 Caernarvon Castle – The Eagle Tower

Watercolour
239 × 290 mm ($9\frac{3}{8}$ × $11\frac{3}{8}$ in)

This shows part of the west front of Caernarvon Castle and the quay and town walls, together with the Watergate and the Eagle Tower. De Wint exhibited three views of Caernarvon at the O.W.C.S. in 1836 of which no. 179, *The Eagel* [sic] *Tower of Caernarvon Castle*, may be related to this drawing. Another view of the castle, taken from the more conventional angle of the south side, is in the City Museum and Art Gallery, Birmingham (115'19); it was exhibited in 1966 at Reading (no. 21). A third drawing is in the Manchester City Art Galleries (1917.125); and two tiny pencil drawings, from a sketchbook, are in the Fitzwilliam Museum (PD.94– & 95–1975). The building of Caernarvon Castle appears to have been begun in 1283 by Edward I; his son Edward, Prince of Wales, was born in the Eagle Tower on 25 April 1284.

Fitzwilliam Museum, Cambridge, PD.53–1966

60 Blackfriars Bridge and St Paul's Cathedral

Watercolour, on paper stamped 'DRAW WATER / ROUGH / THOMAS CRESWICK'
254 × 330 mm (10 × 13 in)
By family descent to the present owner
Exhibited: Vokins, 1884, no. 103; Agnew, 1966, no. 29

Although this is called *Blackfriars Bridge* in Vokins' catalogue, the artist has shown considerable licence in his interpretation of the scene, ensuring that St Paul's dominates the composition. Another watercolour of the same view in a much tighter manner is in a private collection in England.

The Earl of Plymouth

61 Snowscene at Castle Rising, 1836

recto: Black and white chalks, pencil and charcoal with watercolour
verso: Black and white chalks
283 × 382 mm ($11\frac{1}{8}$ × $15\frac{1}{16}$ in)
Inscribed, lower left: '29th Octbr. 1836 / CR.'
From the collection of Miss H. H. Tatlock

De Wint stayed with the Howards at Castle Rising regularly from 1830

onwards. In October 1836 a surprise snowstorm provoked this drawing, presumably done on the spot. From this De Wint worked up the finished drawing in Lord Plymouth's collection (cat. no. 62). He also exhibited a scene called *Hoar Frost at Castle Rising* at the O.W.C.S. in 1837 (no. 48).

Trustees of the British Museum, London, 1913–5–24–36

62 Snowstorm at Castle Rising, 1836

Watercolour, with highlights scratched in
394 × 540 mm (15½ × 21¼ in)
Inscribed on a label on the back: 'A snowstorm at Castle Rising, 29th October 1836 / P. De Wint / 40 Upper Gower St / No. 19'
By family descent to the present owner
Exhibited: O.W.C.S., 1837, no. 108; Vokins, 1884, no. 92; Agnew, 1966, no. 81, repr.

Harriet De Wint mentions in her memoir how attracted her husband was to gypsies. They appealed, presumably, for their 'picturesque' qualities. It is intriguing to see how De Wint has changed the composition of his sketch (cat. no. 61): by removing the uninteresting tub on the right, and bringing forward the smaller tree on the right, placing it in front of the fence, even exaggerating its size, he has improved his original study. The 'gypsies', cow, horse and donkey add a narrative content to the landscape and this with the increased emphasis on the snow has transformed a simple statement of fact into a highly decorative composition. The reviewer in the *Athenaeum* of the 1837 exhibition at the O.W.C.S. did not seem to approve of this more elaborated sort of drawing by De Wint, for he criticises him for a 'superabundance of means which ... obtrude themselves on the attention over prominently at the expense of the subjects painted, [so] that we find less pleasure in the works of 2 of the best practised exhibitors, Messrs De Wint and Barrett, than we ought to find from artists of their admitted talent'.

The Earl of Plymouth

63 Near Lincoln?

Watercolour with gum Arabic, over traces of pencil
261 × 381 mm (10¼ × 15 in)
From the collection of T. W. Bacon

John Clare's manuscript notes for an essay on landscape eloquently describe this sort of drawing. The poet is referring to De Wint: 'look at his sketches his studies there is the simplest touches possible giving the

most natural possible effects the eye is led over the landscape as into an humanity of greetings a beautiful harmony & mystery of pleasant imaginings – there is no harsh stoppages no bounds to space or any outline further than there is in nature – if we could possibly walk into the picture we fancy we might pursue the landscape beyond those mysterys (not bounds) assigned it so as we can in the fields – so natural & harmonious are his perceptions & [?] hints of light & shadows'.

Fitzwilliam Museum, Cambridge, PD.124–1950

64 Coast Scene

Watercolour, over traces of pencil
197 × 340 mm ($7\frac{3}{4}$ × $13\frac{3}{8}$ in)
From the collection of Mr Ashbee
Literature: Victoria & Albert Museum, 1927, *Catalogue of Water Colour Paintings*, p. 167

A view along the east, or possibly the southeast, coast of England. The building in the middle distance appears to be a martello tower. Gypsies are added to give a focus to the foreshore.

Victoria & Albert Museum, London, 1755–1900

65 The Deer Park, Levens

Watercolour
222 × 419 mm ($8\frac{3}{4}$ × $16\frac{1}{2}$ in)
From the collection of W. L. Vicars
Literature: U.G. 1947, pl. xii, no. 9; U.G. 1965, p. 20; U.G. 1972, no. 6
Exhibited: Lincoln, 1937, no. 4; Reading, 1966, no. 17; Agnew, 1966, no. 78

Formerly exhibited as *A View in Cumberland*, this probably shows the deer park at Levens, the home of the Howards, where De Wint often stayed in the 1830s and 1840s.

Lincolnshire Museums: Usher Gallery, Lincoln, UG.702

66 Falls of the Machno, Wales

Watercolour, over pencil with highlights scratched in
464 × 299 mm ($18\frac{1}{4}$ × $11\frac{3}{4}$ in)
Inscribed, *verso*, in pencil: '315; Falls of the Machno, Wales'
From the De Wint sale, Christie's, 1850, no. 315, bought Fripp

De Wint's last visit to Wales was in 1835, to the mountainous district of Caernarvon and Merioneth. This drawing may have been done then, or later, in the artist's studio, worked up from a quick sketch done on the spot. In Thomas Roscoe's *Wanderings through North Wales*, published in 1836, there is an engraving of a drawing of the same mill done by David Cox. De Wint's rendering is much more dramatic, and certainly accords with Roscoe's description of the place: 'I had passed through scenes of the loveliest and the wildest character, yet the falls of the Conway, the Machno, ... excited the imagination and pleased the eye in an extraordinary degree.'

Private collection in England

67 Scalby Mill, near Scarborough, 1838

Watercolour
635 × 553 mm (25 × 21¾ in)
Signed and dated: 'P. De Wint 1838'
By family descent to the present owner
Literature: Armstrong, 1888, pl. 23; *The Studio*, 1903, pl. w. 18
Exhibited: O.W.C.S., 1839, no. 136; Vokins, 1884, no. 79

This finished drawing is exceptional in De Wint's oeuvre in being both signed and dated. It is instructive to compare it with the bold sketch of the *Falls of the Machno* (cat. no. 66). Here, as in the final version of the drawings for the Dublin Society (cat. no. 113), it is the picturesque which is stressed; in the *Falls of the Machno*, the bolder handling suggests the sublime.

The Earl of Plymouth

68 Study of Trees at Lowther

Watercolour with gum Arabic, over traces of pencil
461 × 297 mm (18¼ × 11 11/16 in)
Inscribed, *verso*, in pencil: 'Lowther'
From the collection of T. W. Bacon

The strongly geometric shapes and rhythms and the bold flat colour of this extraordinary drawing seem to anticipate Cézanne in strength of design.

Fitzwilliam Museum, Cambridge, PD.136–1950

69 Lowther, 1839

Watercolour, with highlights scratched in
578 × 451 mm (22¾ × 17¾ in)
From the collections of Miss H. H. Tatlock; Miss G. M. Bostock
Literature: U.G. 1947, no. 32; U.G. 1965, no. 26; U.G. 1972, p. 9,
illustrated back cover
Exhibited: Vokins, 1884, no. 10; Lincoln, 1937, no. 91; Reading, 1966,
no. 26; Agnew, 1966, no. 59

De Wint was a regular guest of the Lonsdales at Lowther. There are
similar studies of swift-running streams in private collections in
England. Harriet De Wint wrote: 'Swift running streams delighted him
much, and the Wharfe, the Lowther, the Dart and others, were studied
with the greatest intensity.'

Lincolnshire Museums: Usher Gallery, Lincoln, UG.875

70 Bolton Abbey

Watercolour
245 × 737 mm (9⅝ × 29 in)
From the collection of Mr Ashbee
Literature: Victoria & Albert Museum, 1927, *Catalogue of Water Colour
Paintings*, p. 167

De Wint exhibited views of Bolton Abbey in 1839, 1845 and 1846. Here,
he has concentrated on the low-lying sweep of a panoramic view,
placing the Abbey, with its hard, solid outlines, on the far left as if it were
entirely incidental to the landscape in which it is set. The drawing is on
two sheets of paper. A priory was endowed by William de Meschines
and his wife Cicely de Romili at Ambsay or Emmesay, near Skipton, in
1120. It was moved to Bolton Abbey in 1151 by their daughter, Alice de
Romili, wife of William FitzDuncan, who gave the manor to the monks
in exchange for other lands. After the dissolution of the monasteries in
1542 the manor was sold to Henry Clifford, through whom it descended
to the Dukes of Devonshire.

Victoria & Albert Museum, London, 1740–1900

71 Bolton Abbey

Watercolour, with highlights scratched in
763 × 1023 mm (30 × 40¼ in) sight size
From the collections of F. W. Smith; E. E. Cook, who presented it
through the N.A.–C.F.
Literature: Leeds Arts Calendar, no. 31, p. 26; O.W.C.S. *Annual*, vol.
XXXV, 1960, p. 21
Exhibited: Agnew, 1924, no. 122; Agnew, 1960, *Watercolours from Leeds*,
ex. catalogue; Reading, 1966, no. 43; Agnew, 1966, no. 1

It is not certain on which occasion this highly finished drawing was
shown at the O.W.C.S., but it was surely intended for such a public
display. As often for this type of drawing, De Wint has chosen a
viewpoint which allows him to stand back and look down upon the vista
below him. This enables the concentration of attention to be focused on
the middle and background of the picture, rather than on the
foreground.

Leeds City Art Galleries

72 Oaks at Oakly Park

Watercolour
667 × 508 mm (26¼ × 20 in)
By family descent to the present owner

The 'Druid Oaks' were painted when De Wint was staying at Oakly
Park with the Hon. Robert Henry Clive, M.P. There are at least six
watercolours of these trees; for apart from the five studies belonging to
various members of the Clive family, exhibited at Vokins' centenary
exhibition in 1884 (nos. 122, 124–7), there was another, sold at the De
Wint sale in 1850 (lot 476). In the O.W.C.S. exhibition at which the
finished drawing, for which these were sketches, was exhibited (no. 1),
in 1841, Harriet De Wint appended the following quotation from *As
You Like It*:

> As he lay along
> Under an oak, whose antique root peeps out
> Upon the brook that brawls along this wood:
> To the which place a poor sequesterd stag,
> That from the hunter's aim had ta'en a hurt,
> Did come to languish.

The Earl of Plymouth

73 Landscape with Cattle Watering

Watercolour
368 × 508 mm (14½ × 20 in)
From the collection of Viscount Crookshank
Literature: U.G. 1972, p. 14
Exhibited: Matlock, 1971, no. 10

The scene has not been identified.

Lincolnshire Museums: Usher Gallery, Lincoln, UG.2431

74 A Mountain Tarn

Watercolour, over traces of pencil with highlights scratched in
219 × 317 mm (8⅝ × 12½ in)
From the collection of Mrs P. Tatlock
Literature: Victoria & Albert Museum, 1927, *Catalogue of Water Colour Paintings*, p. 165

De Wint's mastery of his medium is here shown to superb effect. The paper must have been soaked before he applied pigment, yet the subtle tonal variations are in no way muddied. The slightly denser area of trees in the middle ground, the weeds in the foreground with their cleverly variegated scratchings and the happy placing of the birds balance the composition.

Victoria & Albert Museum, London, 262–1872

75 View near Matlock

Watercolour, with highlights scratched in
305 × 444 mm (12 × 17½ in)
Literature: U.G. 1947, no. 14; U.G. 1972, p. 6
Exhibited: Matlock, 1971, Tawney House – *Peter De Wint*, no. 14

In the *Select Views in Great Britain*, published 1785, there is an engraving after a drawing by De Wint's master, J. R. Smith, which shows the High Tor at Matlock from approximately the same angle as this. The text which accompanies the illustration must have been familiar to De Wint. 'The prodigious Pile Of Rocks, called the *Tor*, stands on the East Side of the River Derwent, nearly opposite *Matlock* Bath, in a winding Vale, bounded on one side by cultivated Slopes, with towering Rocks and pendent Woods on the Other. The River Derwent, takes its varied Course through the Middle of this Vale; in some Places, the stream glides smoothly around the feet of the Mountains, in others it is seen

bounding rapidly over craggy Masses that considerably impede its
Progress; and the Roar of the Torrent is greatly increased by a
Repercussion of the Sound from the high Rocks that overhang it. The
agreeable landscapes, fine Woods, and romantic Prospects, that
everywhere present themselves, forms an elegant Combination of
picturesque Beauty.'

Lincolnshire Museums: Usher Gallery, Lincoln, UG.837

76 High Tor, Matlock

Watercolour, with highlights scratched in
240 × 365 mm (9½ × 14⅜ in)
From the collections of Clarence Harvard; Viscount Crookshank
Literature: U.G. 1972, p. 14
Exhibited: O.W.C.S., 1840, no. 226; Lincoln, 1937, no. 144; Palser
Gallery, 1937, *Peter De Wint and Philip Wilson Steer*, no. 12; Matlock,
1971, Tawney House – *Peter De Wint*, no. 13

De Wint exhibited several views of Matlock in the course of his career.
The problem of his chronology can be pointed by comparing this
drawing, known to have been exhibited in 1840 (and so presumably, but
not necessarily, executed about that year) with the view of *Undercliff, Isle
of Wight* (cat. no. 12), which was engraved in 1814. The treatment of the
cliffs is very similar; and while the handling of the foliage has loosened
and the colour is more individual and bold in the later drawing, there are
still many features in common – not least De Wint's habit of creating
highlights by scratching through his pigment to the whiteness of the
paper.

Lincolnshire Museums: Usher Gallery, Lincoln, UG.2438

77 Gloucester, 1840

Watercolour
610 × 445 mm (24 × 17½ in)
From the collections of Miss H. H. Tatlock; Miss G. M. Bostock
Literature: The Studio, 1903, pl. w. 17; O.W.C.S. *Annual*, 1924, pl. iv;
U.G. 1947, pl. xvii, no. 31; U.G. 1965, p. 16; U.G. 1972, p. 9
Exhibited: Vokins, 1884, no. 4 (or 24); Lincoln, 1937, no. 128; Reading,
1966, no. 29; Agnew, 1966, no. 56; Matlock, 1971, Tawney House –
Peter De Wint, no. 5

The looseness of the drawing in the foreground emphasises the illusion
of distance from the buildings which dominate the middle ground. The
bold way in which they are painted, which recalls early drawings like *Old*

Houses on the High Bridge, Lincoln (cat. no. 4), contrasts strongly with the clarity of the architectural detail in the background. The foundations of the present Cathedral were laid by Abbot Serlo (1072–1104): the building consists of a Norman nucleus with additions in every style of Gothic architecture.

Lincolnshire Museums: Usher Gallery, Lincoln, UG.874

78 Gloucester from the Meadows, 1840

Watercolour
460 × 622 mm (18⅛ × 24½ in)
From the collection of Miss H. H. Tatlock
Literature: Armstrong, 1888, pl. 17; Victoria & Albert Museum, 1927, *Catalogue of Water Colour Paintings*, p. 168, repr. fig. 70; Victoria & Albert Museum, 1929, *Picture Book of Peter De Wint*, pl. 1

A brilliant study manifesting De Wint's mastery of his medium. The nonchalant swabbing of the paper with broad splashes of colour is particularly bold and effective.

Victoria & Albert Museum, London, P.62–1921

79 Lincoln from the Sincil Dyke

Watercolour
152 × 457 mm (6 × 18 in)
Literature: U.G. 1947, pl. xi, no. 10; U.G. 1965, p. 9; U.G. 1972, p. 6
Exhibited: Reading, 1966, no. 44

A double page from a sketchbook, this is a study for *Lincoln from the River Witham*, formerly in the possession of A. H. Gregson, exhibited at Lincoln in 1937, no. 105.

Lincolnshire Museums: Usher Gallery, Lincoln, UG.759

80 A View of Lincoln Cathedral

Brown wash, over traces of pencil
129 × 197 mm (5⅛ × 7¾ in)
From the collections of John Fowler; J. R. Holliday
Literature: Armstrong, 1888, pl. II
Exhibited: Vokins, 1884, no. 152

Although this drawing was presumably done for engraving, no print based on it has been traced. It is one of a group of four drawings of

Lincoln in the same medium in the Fitzwilliam Museum (see also cat. no. 82). Technically it corresponds to the drawings for *Sicilian Scenery* (cat. nos. 27, 28) and for 'The Oxford Almanack' (cat. no. 44), and to the brown wash drawings for the *Graphic Illustrations of Warwickshire* (published 1862) now in the Birmingham City Art Gallery.

Fitzwilliam Museum, Cambridge, 1467a

81 View of the West Front of Lincoln Cathedral, from the Castle Hill, 1841

Watercolour, over traces of pencil with highlights scratched in
1048 × 800 mm ($41\frac{1}{4}$ × $31\frac{1}{2}$ in)
From the collection of Mr Ellison
Literature: R. Redgrave, 1891, *David Cox and Peter De Wint*, facing p. 61; *The Studio*, 1903, pl. w. 30; Sir W. A. Armstrong, 1909, *Art in Great Britain and Ireland*, p. 263; Victoria & Albert Museum, 1927, *Catalogue of Water Colour Paintings*, p. 166; Victoria & Albert Museum, 1929, *Picture Book of Peter De Wint*, pl. 120
Exhibited: O.W.C.S., 1841, no. 175; Lincoln, 1937, no. 101

The magnificent west front of the Cathedral, built *c.* 1225, dominates this very finished watercolour, and its soaring towers bear the eye away from the distracting clutter in the foreground. As in the *Gloucester* of the previous year (cat. no. 77), there is a conscious contrast between the subdued tonality of the buildings clustered round the foot of the Cathedral and the brilliant highlighting on the screen of the west front. Mr Ellison of Sudbrooke Holme was a patron with whom De Wint would sometimes stay. He bought this painting in 1841. Sir Geoffrey Harmsworth pointed out in his catalogue of the 1937 Lincoln exhibition that the carved relief on the monument to De Wint and Hilton in Lincoln Cathedral, designed by Edward Blore, is based on this drawing.

Victoria & Albert Museum, London, 1021–1873

82 View of Lincoln Cathedral

Brown wash, over traces of pencil
126 × 211 mm (5 × $8\frac{5}{16}$ in)
From the collections of John Fowler; J. R. Holliday
Literature: Armstrong, 1888, pl. 1
Exhibited: Vokins, 1884, no. 140

One of the companion drawings to cat. no. 80

Fitzwilliam Museum, Cambridge, 1467d

83 View of Iffley by the River

Watercolour, with highlights scratched in
327×524 mm ($12\frac{7}{8} \times 20\frac{5}{8}$ in)
On loan to the Ashmolean Museum, Oxford
Engraved by W. Radcliffe as the headpiece for 'The Oxford Almanack'
for 1841
Reproduced in colour as the headpiece for 'The Oxford Almanack' for
1914
Exhibited: Reading, 1966, no. 15

By contrast to the other drawings for 'The Oxford Almanack' (cat. no.
44), this is not in brown wash but in watercolour, like *Undercliff, Isle of
Wight* (cat. no. 12). The requirements of the engraver have compelled a
precise attention to detail which is more typical of De Wint's
contemporaries Prout and W. H. Hunt than of his own usual style.

The Delegates of the Clarendon Press, Oxford

84 Sketch in a Garden with a Statue of the Farnese 'Flora'

Black and white chalks with watercolour, over pencil
624×273 mm ($24\frac{9}{16} \times 10\frac{3}{4}$ in)
From the collection of Miss H. H. Tatlock

On two sheets of paper, this, one of a group of drawings presented to the
British Museum by De Wint's grand-daughter, from those which
Harriet De Wint had declined to sell in 1850, is one of De Wint's most
brilliant out-of-door sketches of trees. The cast of the Farnese 'Flora'
should indicate the garden, perhaps at Lowther.

Trustees of the British Museum, London, 1913–5–24–13

85 Sketch of a Tree

Watercolour, with black chalk and white bodycolour
532×371 mm ($21 \times 14\frac{5}{8}$ in)
From the collection of Miss H. H. Tatlock

A group of studies of trees was sold at Christie's in 1850; they may have
been similar to this. The rough wash in the background provides an
effective tonal contrast to the shimmering tree, giving it a sense of
volume and setting it in space with effortless ease. A measure of De
Wint's range and accomplishment appears by comparison of this

drawing with the no less effective but entirely different study of *Trees at Lowther* (cat. no. 68). This study may also have been drawn at Lowther (cf. *Harvest Time, Lowther in the Distance*, Armstrong, pl. 16), or possibly at Ashtead Park, as a similar study exists in the Yale Center for British Art (B.1977.14.524) for which an old label reads 'Tree study in Ashtead Park *c.* 1847'.

Trustees of the British Museum, London, 1913–5–24–8

86 A Lancashire Cornfield

Watercolour
295 × 464 mm ($11\frac{5}{8}$ × $18\frac{1}{4}$ in)
From the collections of Lady Broadhurst; Miss H. Barlow
Exhibited: Huddersfield, 1946; Arts Council, 1948; Scandanavia, 1949, British Council; Delft Museum and Art Gallery, Holland, 1952

The richness of the freshly cut corn is echoed throughout this drawing by the pools of saturated colour which lead the eye effortlessly to the furthest distance. Despite very English qualities in the technique, the long low horizon shows a continuing Dutch influence.

Whitworth Art Gallery, University of Manchester, D.39–1924

87 Shamblands

Watercolour
323 × 489 mm ($12\frac{5}{8}$ × $19\frac{1}{4}$ in)
Inscribed 'Shamblands' beneath the backing paper in the artist's hand

De Wint's trick of blurring the foreground so that attention is held by the middle ground and the eye led into the distance is here particularly successful. 'Shamblands' has not been identified, nor is it known how it got its name.

Private collection in England

88 Dunster Castle, Somerset

Watercolour, over traces of pencil
279 × 457 mm (11 × 18 in)
From the collection of Sir Charles Sydney Jones

De Wint exhibited a view of Dunster in 1844 at the O.W.C.S. (no. 104).

36

The castle is of thirteenth-century origin, and the Church of St George, visible in the middle ground, has Norman portions but is in the main built in the perpendicular style. The roof of the house in the foreground is handled in an identical way to that of a similar building in a drawing of Minehead in the Fitzwilliam Museum dated 1842 (no. 1465). Minehead is only a mile and a half away from Dunster, so this drawing may have been made at the same time.

The University of Liverpool, 66/3593

89 Near Bridgenorth, Shropshire

Watercolour, with highlights scratched in
521 × 864 mm (20½ × 34 in)
From the collections of William Leach; E. M. Denny; J. D. Ruddock
Literature: U.G. 1972, p. 12
Exhibited: Manchester, 1857, *Art Treasures Exhibition*; Norwich Castle Museum, 1956, *Watercolours by British Landscape Painters*, no. 36; Agnew, 1966, no. 3; Matlock, 1971, Tawney House – *Peter De Wint*, no. 15

There are regular sales in the 1840s of views in Shropshire recorded in Mrs De Wint's account books, but none of the titles listed accords with this view. In her memoir Harriet De Wint says: 'He admired Shropshire, which country he frequently visited, having many friends there, and he spent a good deal of time in the neighbourhood of Bridgenorth ... He made many excursions with the Marquis of Ailesbury, whom he found a most kind patron and friend.' This drawing is clearly based on Thomas Gainsborough's landscapes.

Lincolnshire Museums: Usher Gallery, Lincoln, UG.1926

90 At Minehead, 1841

Watercolour, over traces of pencil with highlights scratched in
294 × 467 mm (11$\frac{9}{16}$ × 18$\frac{3}{8}$ in)
From the collection of Miss H. H. Tatlock
Literature: E. B. Lintott, 1926, *Art of Watercolour Painting*, facing p. 243; Victoria & Albert Museum, 1927, *Catalogue of Water Colour Paintings*, p. 168

The delicacy of treatment of the leaves on the tree on the left contrasts most expressively with the clumped mass of foliage to the right of the tavern.

Victoria & Albert Museum, London, P.63–1921

91 'Round Church in Essex'

Watercolour
306 × 482 mm (12⅛ × 19 in)
From the collection of Sir Charles Sydney Jones

It has not been possible to identify this scene, traditionally called a round church in Essex. It may represent the remains of a fortified house and bears some resemblance to Goodrich Castle.

The University of Liverpool, 66/3592

92 Harvesting

Watercolour, over traces of pencil with highlights scratched in
360 × 532 mm (14¼ × 21 in)
From the collection of Mrs Bertha Elizabeth May Martland, given by Miss Sarah Martland
Exhibited: Agnew, 1924, *Turner, Cox and De Wint,* no. 50; Lincoln, 1937, no. 158

The detailed studies of trees which De Wint made from time to time like those of the Druid Oaks at Oakly Park (cat. no. 72) were fundamental in enabling him to master details like that of the gnarled tree on the right. Its very understatement shows a complete understanding of the complexities of its form.

Whitworth Art Gallery, University of Manchester, D.13–1969

93 Loading a Hay Barge on the Trent near Burton

Watercolour, with highlights scratched in
207 × 433 mm (8⅛ × 17 1/16 in)
From the collection of John Henderson
National Gallery Loan no. 14
Literature: Victoria & Albert Museum, 1927, *Catalogue of Water Colour Paintings,* p. 169
Exhibited: Burlington Fine Arts Club, 1873, *David Cox and Peter De Wint,* no. 63

De Wint is perhaps most associated with scenes of haymaking. The pools of light which irradiate the surface give a splendid recession to the landscape and recall Girtin. The summary treatment of the trees, contrasting blocks of differing tones, is masterly.

Tate Gallery, London, 3490 (transferred 1929)

94 Cornfield, Windsor, 1841

Watercolour with gum Arabic, over traces of pencil
290 × 461 mm ($11\frac{7}{16}$ × $18\frac{1}{8}$ in)
Inscribed, *verso*, in pencil: 'Windsor / August 1841' in the artist's hand
From the De Wint sale, 1850, lot 319, bought by Smith. From the collection of T. W. Bacon
Exhibited: O.W.C.S., 1842, no. 239; Louisville, Kentucky, Speed Art Museum, 1977, *British Watercolours: A Golden Age, 1750–1850*, no. 84

The density of colour, particularly the purplish haze which shrouds the castle, gives the impression of sizzling heat. As John Clare wrote: 'It is summer the very air breaths hot in ones face.' Lord Plymouth has a similar drawing of harvesters with Windsor Castle in the background.

Fitzwilliam Museum, Cambridge, PD.129–1950

95 Harvesting

Watercolour, over pencil
206 × 262 mm ($8\frac{1}{8}$ × $10\frac{5}{16}$ in)
Inscribed in pencil, upper right: '65'
From the collection of T. W. Bacon

A fascinating opportunity to compare the rather clumsy drawing of the horse in the foreground to the right with the effective wash drawings of horses in front of the hay-wain. Here the bold application of dark highlights on the loose wash clarifies and defines the horses' forms. Like cat. no. 96, this is probably a study for a more finished drawing; it has much the same charm as the figure drawing (no. 51).

Fitzwilliam Museum, Cambridge, PD.139–1950

96 Harvesters Resting Colour plate IV

Watercolour with gum Arabic, over pencil
324 × 340 mm ($12\frac{3}{4}$ × $13\frac{3}{8}$ in)
From the collection of J. R. Holliday

This is a full-size study for the left-hand section of the painting in the collection of Sir Ian Forbes Leith of Fyvie, Bart.

Fitzwilliam Museum, Cambridge, 1583

97 Church Steeple, Wombourne, Staffordshire, 1842

Watercolour, over pencil
254 × 355 mm (10 × 14 in)
Inscribed, lower left in the artist's hand: 'Wombourne / Sept 1842'
Literature: U.G. 1947, mo. 25; U.G. 1972, p. 9

In this sketch, done on the spot, De Wint contrasts a loose treatment of the immediate foreground with a tight handling of architectural detail, as in *Gloucester* (cat. no. 77). The background, which he has hardly delineated, seems to stretch to infinity.

Lincolnshire Museums: Usher Gallery, Lincoln, UG.864

98 Brougham Castle Colour plate V

Watercolour with gum Arabic, over traces of pencil
291 × 459 mm (11$\frac{7}{16}$ × 18$\frac{1}{16}$ in)
Inscribed, *verso*, in pencil: 'Brougham Castle' '424'
From the De Wint sale, Christie's, 1850, lot 424, bought by Smith. From the collection of Arthur W. Young

Any doubts as to the authenticity of this drawing were dispelled when recently it was removed from its old mount and the inscription in Harriet De Wint's hand was revealed, along with the lot number. The colours, which are in brilliant state, have an opulence characteristic of De Wint's sketches from the 1830s onwards. The handling of the running water on the left resembles that in his dated sketch of 1848 for *On the Dart* (cat. no. 123). Brougham Castle in Westmorland was largely built by Roger de Clifford in the reigns of Henry III and Edward I. It was damaged in the Civil Wars and repaired in 1651–2 by Lady Anne Clifford. After it passed by marriage to John, Lord Tufton, later Earl of Thanet, it gradually fell into disrepair and was allowed to become a ruin. De Wint exhibited a *View of Brougham Mill, Westmorland* in 1843 (no. 194).

Fitzwilliam Museum, Cambridge, 1794

99 A View in the Lake District Colour plate VI

Watercolour
292 × 455 mm (11$\frac{1}{2}$ × 17$\frac{15}{16}$ in)
Inscribed, *verso*, in pencil: 'Westmoreland / 365'
From the De Wint sale, Christie's, 1850, lot 365, bought by Vokins.

From the collections of Messrs Palser; T. W. Bacon
Exhibited: R.A., 1934, *British Painting*, no. 879, commemorative catalogue no. 851; Lincoln, 1937, no. 211; Reading, 1966, no. 52; Agnew, 1966, no. 103

This characteristic example of De Wint's loosest style, presumably executed when he was staying at Lowther with the Lonsdales or at Levens with the Howards, was exhibited at both the Royal Academy and at Lincoln as *A View in the Lake District*. De Wint's preference for a rough paper is again apparent. Indeed, on a smooth paper such rich subtleties and modulation of tone would have been almost impossible to produce. The elegant coloured washes of Francis Towne, for which smooth paper is so necessary a support, are far from the romantic atmosphere De Wint has created.

Fitzwilliam Museum, Cambridge, PD.135–1950

100 Cumberland Hills from Patterdale

Watercolour, over pencil
153 × 647 mm (6 × 25½ in)
From the collection of Sir E. Tooth Broadhurst
Exhibited: Agnew, 1954, *Watercolour Drawings from the Whitworth Art Gallery*, no. 84; Reading, 1966, no. 45; Abbotts Hall, 1967; Brussels, 1973; Russia, 1974; *Lakeland Drawings*, 1977

Presumably from a sketchbook, the drawing being joined down the middle. De Wint's obsession with extended landscape, which may have a subconscious origin in his Dutch ancestry, here takes him even further than Koninck in a presentation of unobstructed and uninterrupted vista.

Whitworth Art Gallery, University of Manchester, D.63–1924

101 The Snow-Drift

Watercolour, with highlights scratched in
317 × 747 mm (12½ × 29⅜ in)
From the collection of Mr Ellison
Literature: Victoria & Albert Museum, 1927, *Catalogue of Water Colour Paintings*, p. 166

This is one of the most narrative of all De Wint's compositions. Although it has not a 'programme' like the now missing *Elijah* of 1829, for which the preliminary drawings survive in a notebook still in private hands, this painting could almost be an illustration for Pickwick. It is hardly surprising that it should have proved sufficiently popular for Sir

Frank Short to produce a mezzotint after it. The long low-lying mountains in the background show to what purpose a sketch like that of *Cumberland Hills from Patterdale* (cat. no. 100) could be put. Mr Ellison paid thirty guineas in 1842 for a painting titled *It Was a Winter Evening*, which may perhaps be this. Four other drawings exhibited between 1839 and 1844 may also be related, and the quotation appended to no. 15 of 1842 is certainly descriptive of such a scene as this. It is from Thomson's

Winter:
 From the bellowing East,

In this dire season, oft the whirlwind's wing
Sweeps up the burden of whole wintry plains
At one wide waft.

Victoria & Albert Museum, London, 1022–1873

102 The Clee Hill, Shropshire

Watercolour
381 × 527 mm (15 × 20¾ in)
From the collection of the late Sir Hickman Bacon
Literature: A. P. Oppé, 1952, *Early English Watercolours*, pl. cxxxviii
Exhibited: Agnew, 1924, *Turner, Cox and De Wint*, no. 68; Agnew, 1946, no. 80; Norwich, 1956, no. 37; Agnew, 1966, no. 108

Presumably made while De Wint was staying with the Clives at Oakly Park (cat. no. 107). De Wint exhibited two views of Clee Hill at the O.W.C.S. in 1844 and 1847 respectively. The acid colour and barely hinted outlines of trees make this one of his most elusively atmospheric drawings.

103 The Staith, Lincoln

Watercolour
120 × 368 mm (4½ × 14½ in)
From the collection of Viscount Crookshank
Literature: U.G. 1972, p. 14

John Clare's notes for his *Essay on Landscape* include the following passage which could well describe this limpid sketch from two sheets of a notebook. 'In contemplating the scenery of Dewint's pencil we see natural objects not placed for effect and set off by dictates of the painter's fancys but there they are just as nature placed them.' The same comments about dating apply to this drawing as to cat. no. 104.

Lincolnshire Museums: Usher Gallery, Lincoln, UG.2439

104 Sunset

Watercolour with gum Arabic, over pencil
231 × 420 mm ($9\frac{1}{8}$ × $16\frac{1}{2}$ in)
From the collection of T. W. Bacon
Exhibited: Amsterdam, 1931, *Twee Eeuwen Engelse Kunst*, no. 214;
Reading, 1966, no. 63; Agnew, 1966, no. 76

In Amsterdam this was exhibited as a view of Kirkby Lonsdale, but it has also been suggested that Lea church is represented. The dating is problematic. The looseness and the extreme daring with which the washes of colour are allowed to run into one another demand the greatest technical mastery. This and the colour range argue a late date, backed by the appearance in the O.W.C.S. exhibitions of 1844 and 1845 of two paintings entitled *Evening* to which it might be possible to relate this drawing. On the other hand there are many similarities of effect with the view of *Lincoln from the River* (cat. no. 15), which on the analogy of the use of watercolour as if it were oil, and the weaknesses in draughtsmanship of the middle distance, bears close comparison with the drawings from the 1816 sketchbook. On balance a later date seems more probable, but without documentation it is unwise to be dogmatic. Indeed, cat. no. 15 may be late as well.

Fitzwilliam Museum, Cambridge, PD.123–1950

105 Roper Gate, Canterbury

Watercolour with gum Arabic
151 × 264 mm ($5\frac{15}{16}$ × $10\frac{3}{8}$ in)
From the collection of T. W. Bacon

Mrs De Wint's account books show the sale of a drawing of Canterbury in 1846, presumably the one he exhibited in the same year. The one surviving gate of the old city walls is of fourteenth-century origin.

Fitzwilliam Museum, Cambridge, PD.118–1950

106 The Constable's Tower, Dover Castle, 1845

Watercolour, over traces of black chalk
295 × 459 mm ($11\frac{5}{8}$ × $18\frac{1}{16}$ in)
Inscribed in pencil, *verso:* 'Dover Castle / 29th August 1845'
Literature: Principal Pictures in the Fitzwilliam Museum, 1929, p. 244

Cold grey greens and the bold placing of all the weight of the drawing off

centre to the left emphasise the rugged austerity of this noble castle. The blocking of tone on the left recalls the handling of the *Study of Trees at Lowther* (cat. no. 68). Samuel Palmer may have had this sort of drawing in mind when he wrote in his notebook in 1850 'try something like the solid BLOCKS of sober colour in De Wint'. The constable's tower was one of the subsidiary defences of the Norman castle.

Fitzwilliam Museum, Cambridge, 1127, given by the Friends of the Fitzwilliam Museum

107 Panoramic View of Clee Hill, seen from the River Teme

Watercolour, with traces of pencil
280 × 915 mm (11 × 36 in)
By family descent to the present owner
Exhibited: Vokins, 1884, no. 55; Agnew, 1966, no. 99

This panoramic view of Titterstone Clee Hill was taken from the left bank of the River Teme (at right) just below the house the far side of the former wooden bridge. A distant view of Clee Hill was exhibited at the O.W.C.S. in 1847 (no. 7).

The Earl of Plymouth

108 A View of Matlock

Watercolour
356 × 546 mm (14 × 21½ in)
From the collection of the late Sir Hickman Bacon
Exhibited: Agnew, 1934, *Turner, Cox and De Wint*, no. 71; Agnew, 1946, no. 77; Agnew, 1966, no. 67

The countryside near Matlock was a constant source of inspiration to De Wint, as this and cat. nos. 114, 115 and 116 witness. Like the view of Clee Hill (cat. no. 102), this drawing has a poetic sensibility which cannot help remind one that De Wint was much concerned with literature. Apart from inspiring the effusions of John Clare, he was more than a passing acquaintance of both Keats and De Quincey, and the poets quoted by Harriet as comments on his exhibited works range from Shakespeare to Wordsworth, *via* Milton, Collins, Thomson and Scott.

109 A Ruined Castle

Watercolour
237 × 356 mm ($9\frac{5}{16}$ × 14 in)
Part of the stamp of the Royal Dublin Society, lower right
From the collection of the Royal Dublin Society

Armstrong records that in 1834 De Wint 'accepted from the Royal Dublin Society, a sum less than half what he had asked for eight of his drawings, begging them to consider the balance his contribution to their work'. The Royal Dublin Society was founded in 1683, based on the Royal Society which had been founded in London in 1660. It received a charter in 1750 and in 1758 the drawing school was founded. It was to help the students of the society that De Wint agreed to reduce his prices, an action of singular generosity in the light of the stories which were handed down about his particular attention to money. Letters relating to this and the drawings which were subsequently sent to Ireland are in the Usher Gallery, Lincoln. De Wint called this drawing a ' "Blot" , such as a young artist is recommended to make before commencing his picture in order to try the quantities of light and shade, as well as the proportions of warm and cool colours'. The similarity of this to some of Turner's more fluid sketches, like *The Yellow Castle* in the Fitzwilliam Museum, can hardly be accidental.

National Gallery of Ireland, 3927

110 The Art of Drawing No. 1

Watercolour
513 × 363 mm ($20\frac{1}{4}$ × $14\frac{5}{16}$ in)
From the collection of the Royal Dublin Society

National Gallery of Ireland, 3903

111 The Art of Drawing No. 2

Watercolour
514 × 368 mm ($20\frac{1}{4}$ × $14\frac{1}{2}$ in)
From the collection of the Royal Dublin Society

National Gallery of Ireland, 3904

112 The Art of Drawing No. 3

Watercolour
511 × 368 mm (20⅛ × 14½ in)
From the collection of the Royal Dublin Society

National Gallery of Ireland, 3905

113 The Art of Drawing No. 4

Watercolour, with highlights scratched in
510 × 369 mm (20 1/16 × 14 9/16 in)
From the collection of the Royal Dublin Society

National Gallery of Ireland, 3906

In continuation of the passage from Armstrong quoted above (cat. no. 109) he adds: '. . . and three years later we find him agreeing to make a set of examples for the "students in the society's school, also at a reduction from his usual rate of payment" '. The result of De Wint's generosity can be seen in cat. nos. 110–13, which were received by the Royal Dublin Society in December 1846. Apart from oral descriptions from pupils like Mr Heathcote, quoted by Armstrong, these four drawings, the 'Blot' (cat. no. 109) and certainly two (nos. 3975 and 6016) if not eight other drawings in the National Gallery of Ireland, are the only certain evidence of De Wint's teaching methods. By examining them in sequence it is possible to see how De Wint gradually elaborates his composition. 'No. 1' shows the principal elements in terms of light and dark. Light reflects off the surface of the rocks, defining them almost in a cubist manner. In comparison with this, the trees and play of the water are secondary in importance. In 'No. 2' the dark areas are intensified, the water is given a greater sense of definition, the trees have more density. This is achieved both through tonal contrast and by a juxtaposition of alternating techniques. The central area of the tree on the left is washed in blotches of different tones, one superimposed lightly on the other and dragged across the paper on a brush loaded in such a way as to splutter, producing uneven highlights of flickering density. The rock which gashes the falls is darkened and its form is made more weighty. In the background is the first glimpse of a mill. 'No. 3' dances with light and dark tones as the elaboration of the composition continues. The spatial definition becomes more certain as the tones intensify, dark contrasting with light. The water sparkles into life; there is a great sense of movement in the foreground and the ghost of a hill behind the mill extends the depth of the picture. The finished drawing is much more

detailed; the bark of the silver birch appears, like a new skin on a snake, and the massive rocks on the right lose their abstract form and appear clothed. The jutting rock, hitherto dominant in the foreground, is counterbalanced by the scratching out of water in the falls on the left. The bank in the left foreground has finally materialised, and the mill gives a focus of brilliant light to the near distance – rather like the effect of the White House in Girtin's *Chelsea*. The final effect may not appeal to modern eyes in quite the same way as the earlier stages of the composition; in fact, the criticism already quoted from the *Athenaeum* of 1837 (cat. no. 62) is relevant here, too: 'It is in the superabundance of *means* which . . . obtrude themselves on the attention over prominently at the expense of the subjects painted, that we find less pleasure in the works of . . . the best practised exhibitors . . . than we ought to find from artists of their admitted talent.' In other words, the sum of the parts is greater than the whole – perhaps; although De Wint never loses sight of the central structure of his composition. Everything is measured by light, warm and cold, and this measure provides the underlying sense of volume.

114 Near Matlock

Watercolour with gum Arabic, over black chalk
253 × 358 mm (10 × 14⅛ in)
Inscribed, *verso*, in pencil: 'Near Matlock'
From the collection of T. W. Bacon

The brilliant intensity of the reds and blues which illuminate this watercolour gives a sensation of sultry heat. A drawing of *Matlock Village* was exhibited at the O.W.C.S. in 1847.

Fitzwilliam Museum, Cambridge, PD.126–1950

115 On the River Derwent, near Matlock, Bath

Watercolour with gum Arabic, over traces of black chalk
285 × 459 mm (11 3/16 × 18 1/16 in)
Inscribed, *verso*, in pencil: 'Matlock' '421'
From the De Wint sale, Christie's, 1850, lot 421, bought Vokins. From the T. W. Bacon collection
Exhibited: Reading, 1966, no. 78

Views of Matlock were exhibited at the O.W.C.S. in 1846 and 1849. Unlike the earlier views of Matlock (cat. nos. 75 and 76), this drawing makes no play with the picturesque features. The strength and the

quality of brooding disquiet which are expressed here are more attuned to the sublime. The reviewer of the *Athenaeum* wrote of one of De Wint's watercolours in 1847: '... how much of detail may be indicated by slight means if the execution be bold and broad. Mr De Wint is the very Wilson of watercolour painters, viewing his pictures at a proper distance. The inequalities of the foreground ... are expressed in rich and deep colour with appropriate and masterly handling.'

Fitzwilliam Museum, Cambridge, PD.127–1950

116 Vale in Derbyshire

Watercolour
229 × 686 mm (9 × 27 in)
From the collection of the late Sir Hickman Bacon

On two sheets of paper, the effect is of the previous view of Matlock (cat. no. 115) opened out. The sense of claustrophobia implicit in the dark tones and off-centre placing of no. 115 is lost, and we are given a breathtaking view of the very heart of Derbyshire. As in No. 3 of the *Art of Drawing* series (cat. no. 112), the overall impression is of light. It sparkles brilliantly, skims the surface of the paper, pausing for a moment on a detail only to be smothered by an overwhelming mass of dark tonality. It then reappears, teasing, in another passage of the drawing. A fine example of what the reviewer of the *Athenaeum* in 1848 calls 'the great and singular power the artist possesses of producing by very simple means the effect of detail in character and species'.

117 Walton-on-Thames

Watercolour, with highlights scratched in
340 × 889 mm (13⅜ × 35 in)
From the collection of Mr Ellison
Literature: The Studio, 1903, pl. w. 11; Victoria & Albert Museum, 1927, *Catalogue of Water Colour Paintings*, p. 165
Exhibited: O.W.C.S., 1848, no. 119

It is interesting to compare this with earlier views upon the Thames (cat. nos. 2, 14, 46). De Wint's manner has become more precise; but he is still attracted by the same broad reaches of riverscape, and succeeds in combining 'happy artistic effects and fidelity to nature'. Mrs De Wint's account book records the sale to Mr Ellison in 1848.

Victoria & Albert Museum, London, FA.517

118 Bray on Thames

Watercolour
229 × 457 mm (9 × 18 in)
From the collection of Sir Charles Sydney Jones

The University of Liverpool, 223

119 Study for Bray on Thames

Watercolour, over traces of pencil
263 × 464 mm ($10\frac{3}{8}$ × $18\frac{1}{4}$ in)
From the collection of John Henderson
National Gallery Loan no. 6
Literature: Victoria & Albert Museum, 1927, *Catalogue of Water Colour Paintings*, p. 168; Victoria & Albert Museum, 1929, *Picture Book of Peter De Wint*, pl. 15
Exhibited: Burlington Fine Arts Club, 1873, *David Cox and Peter De Wint*, no. 67

Tate Gallery, London, 3482

120 Bray on Thames

Watercolour, with highlights scratched in
371 × 648 mm ($14\frac{5}{8}$ × $25\frac{1}{2}$ in)
From the collection of John Henderson
National Gallery Loan no. 11
Literature: Victoria & Albert Museum, 1927, *Catalogue of Water Colour Paintings*, p. 168
Exhibited: Burlington Fine Arts Club, 1873, *David Cox and Peter De Wint*, no. 60

There is also a version of *Bray on Thames* in the City Art Gallery, Birmingham; one of these three is probably that exhibited in 1849 (no. 178) of which the *Athenaeum* reviewer wrote: 'As we have before observed, this painter's style resembles that of Richard Wilson ... Bray on Thames (178), though sketchy, is full of science.' On the analogy of this description, no. 118 and no. 120 (with its study) are both candidates, but the larger size of 120 weighs more in its favour. It is clear that, despite personal illness, De Wint ended his career on as calm a note as he began it. Slow-flowing, tranquil waters with limpid reflections, presented in a panorama reminiscent of Dutch paintings and redolent of summer, remain the essence of his style. Indeed the comment in his

obiuary which prefaces this catalogue still rings true. 'He sent his first works to the O.W.C. exhibition of the year 1810. These were in character and feeling not unlike the works which he contributed to the exhibition still open [1849].'

Tate Gallery, London, 3487

121 On the Dart

Blue-grey wash with sepia
198 × 305 mm ($7\frac{3}{4}$ × 12 in)
From the collection of Sir Geoffrey Harmsworth
Literature: U.G. 1947, no. 27; U.G. 1972, p. 9

This is a preliminary study for the painting exhibited at the O.W.C.S. in 1849 (no. 38), cat. no. 124. The use of a two-toned wash enables De Wint to gauge 'the quantities of light and shade, as well as the proportions of warm and cool colours', as he recommended in his 'Blot' drawing (cat. no. 109).

Lincolnshire Museums: Usher Gallery, Lincoln, UG.866

122 On the Dart

Watercolour
243 × 338 mm ($9\frac{9}{16}$ × $13\frac{5}{16}$ in)
From the collection of R. M. M. Pryor, M.B.E., T.D., M.A., given through the Friends of the Fitzwilliam Museum, in memory of his brother, Dr Mark Pryor of Trinity College, Cambridge

Another study for the painting, cat. no. 124. Of the three studies exhibited here, this is the closest in detail to the finished drawing. The viewpoint has been altered from that shown in no. 121 to extend the foreground; the grouping of the cattle and the figure in the middle distance have been changed. Two small brown ink drawings both on envelopes addressed to P. de Wint Esq, 40 Upper Gower St, which appear to have been De Wint's first ideas for the composition, were sold at Christie's 2 March 1976.

Fitzwilliam Museum, Cambridge, PD.3–1977

123 On the Dart, 1848 Colour plate VII

Watercolour with gum Arabic, over traces of pencil
330 × 505 mm (13 × 19⅞ in)
Verso, inscribed in the artist's hand: 'Holme Chase on the River Dart,
Devonshire / 9th Sept. 1848'
From the collection of T. W. Bacon
Exhibited: Reading, 1966, no. 38; Agnew, 1966, no. 55

A study for the water in the painting exhibited in 1849. This may well be
De Wint's last study from nature, as T. W. Bacon noted on the old
mount. De Wint went to Devonshire in the autumn of 1848. It was his
last major excursion into the country. A projected visit to Lincoln was
cancelled because of his ill healthᵇ

Fitzwilliam Museum, Cambridge, PD.121–1950

124 On the Dart Colour plate VIII

Watercolour with traces of gum Arabic, heightened with white
557 × 946 mm (21 15⁄16 × 37¼ in)
From the collections of Messrs Vokins; Stephen Holland; Sidney
Holland
Literature: Armstrong, 1888, pl. 21; *Apollo*, Feb. 1977, vol. CV, no. 180,
p. 142, fig. 6
Exhibited: O.W.C.S., 1849, no. 38; Vokins, 1884, no. 83; Guildhall,
London, 1896, *Loan Exhibition of Watercolour Drawings*, no. 39; Agnew,
104th Annual Exhibition of Watercolours and Drawings, 1977, no. 83

Recently, when the drawing was cleaned, it was discovered that it had
been laid down on a piece of canvas on which De Wint had sketched out
a preliminary design for an oil painting. This is the finished drawing for
which cat. nos. 121–3 were studies. From the inscription on no. 123 the
view can be identified as Holme Chase on the River Dart; the artist has
taken considerable licence with the scene, however, extending the
bridge, adding the water-mill on the left and raising the line of the hills
on the horizon. This drawing has always been considered the last major
work the artist completed, and it must have been gratifying that the
reviewer in the *Athenaeum*, who had not always lingered over De Wint's
drawings, should have singled it out: 'Mr De Wint's drawings this year
are as remarkable for breadth and handling as any we have hitherto seen
by him [compare also cat. no. 120]. He has never surpassed the large
view on the River Dart in Devonshire (38). The breadth of its light and
shade is admirable. The water is delicious; and the drawing is expressive
of all the best attributes of De Wint's art.' And what are the 'best

attributes of De Wint's art'? John Clare's sonnet to De Wint was written some twenty years earlier, but its opening lines answer that question and are still a pertinent gloss on the painter's latest work:

De Wint I would not flatter nor would I
Pretend to critic skill in this thy art
Yet in thy landscapes I can well descry
Thy pencil's hues as nature's counterpart
No painted freaks no wild romantic sky
No rocks or mountains as the rich sublime
Hath made thee famous – but the sunny truth
Of nature that doth mark thee for all time . . .

Fitzwilliam Museum, Cambridge, PD.5–1977, bought from the Fairhaven Fund

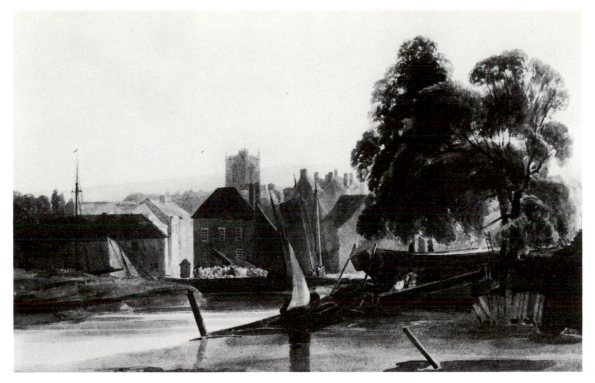

Cat. no. 1

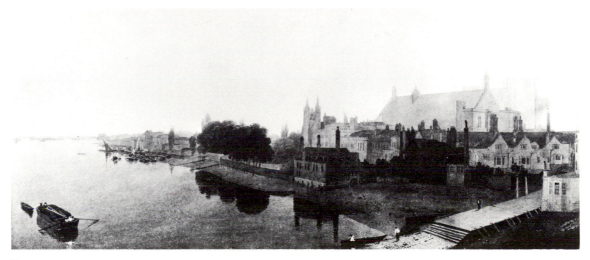

Cat. no. 2

Plate no. 2

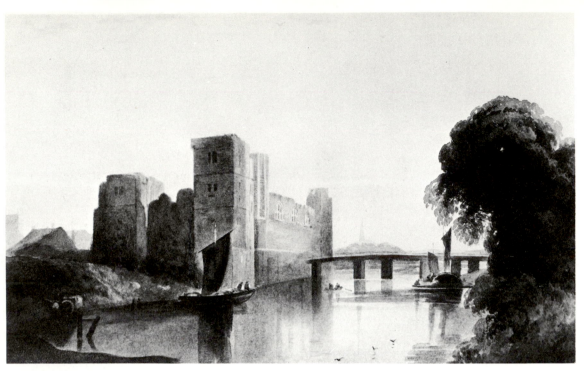

Cat. no. 3

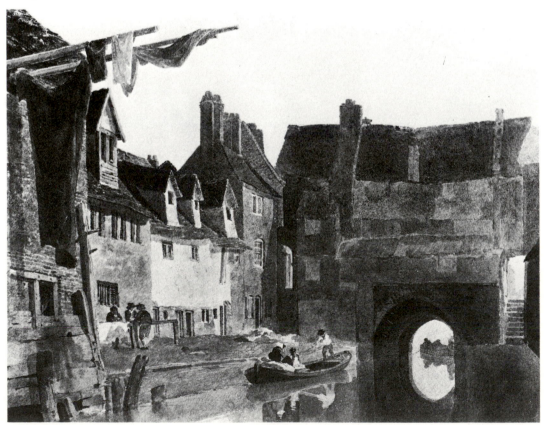

Cat. no. 4

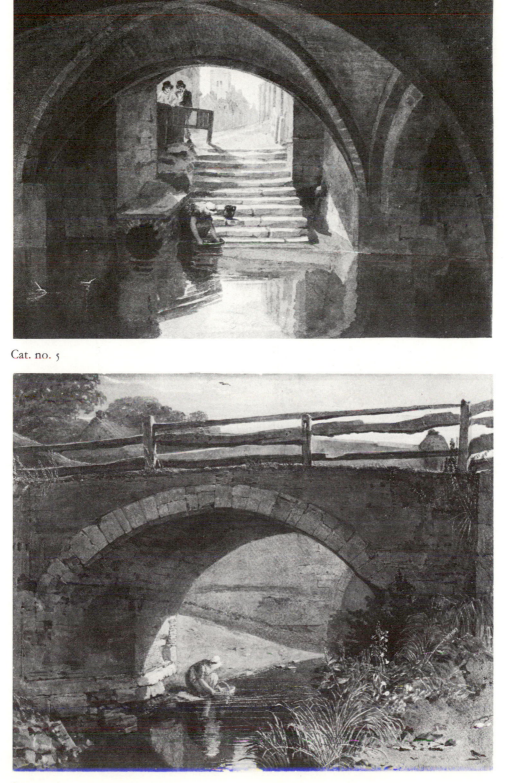

Cat. no. 5

Cat. no. 6

Plate no. 4

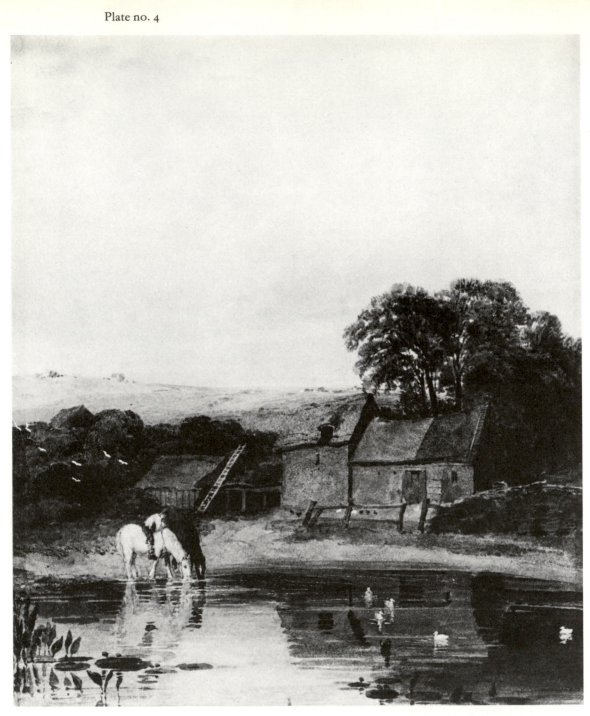

Cat. no. 7

Cat. no. 8

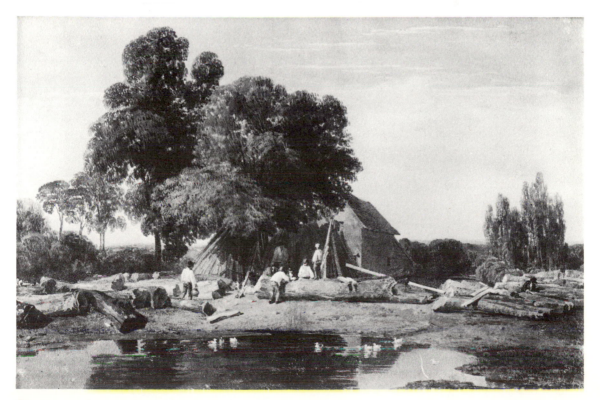

Cat. no. 9

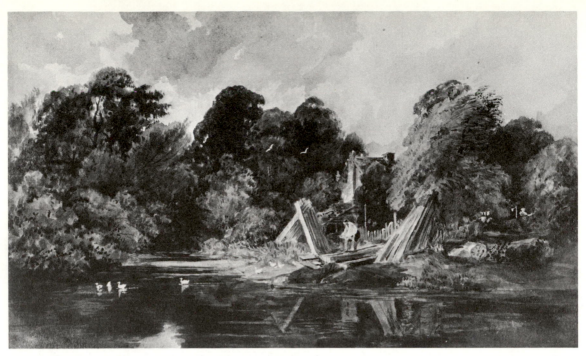

Cat. no. 10

Cat. no. 11 : *see* Colour plate I

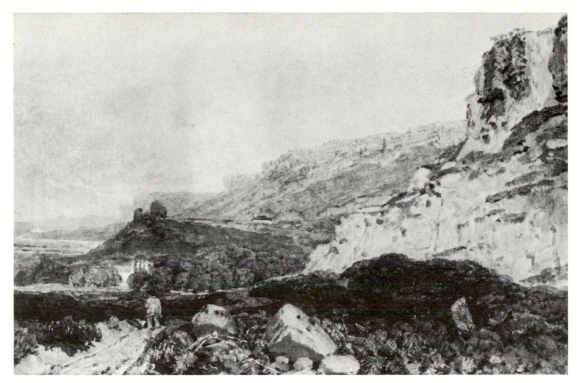

Cat. no. 12

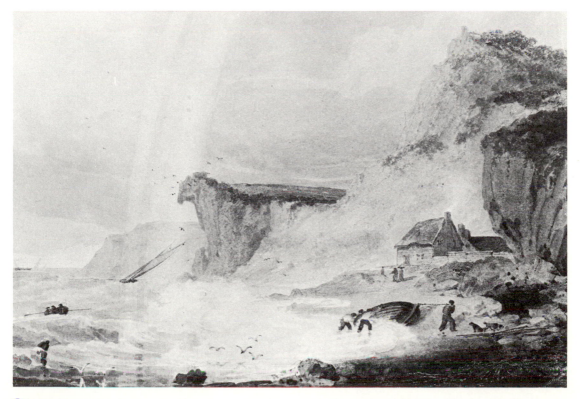

Cat. no. 13

Cat. no. 14

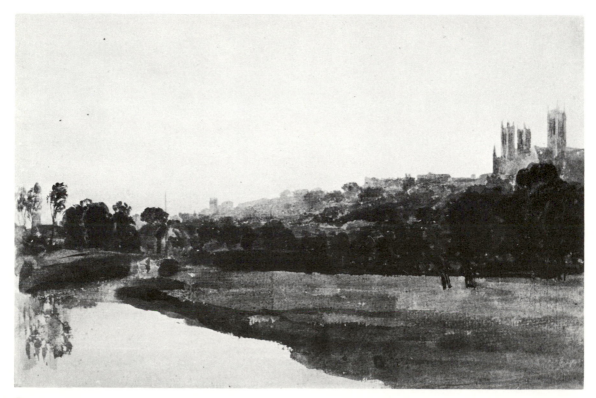

Cat. no. 15

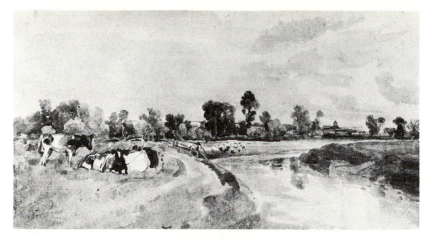

Cat. no. 16

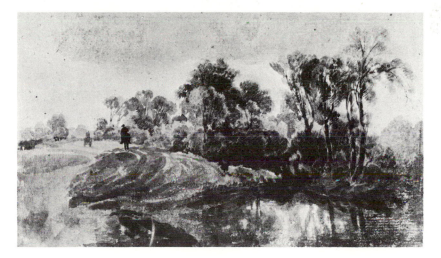

Cat. no. 17

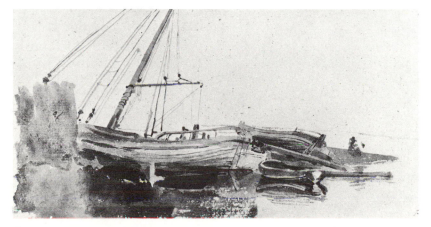

Cat. no. 18

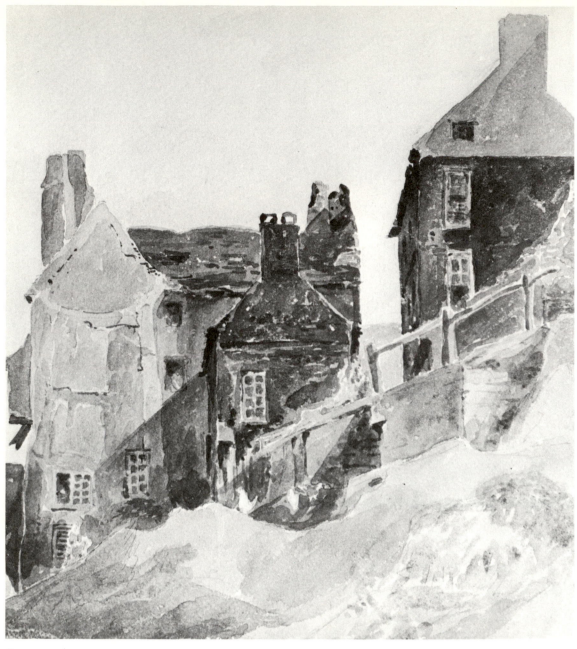

Cat. no. 19

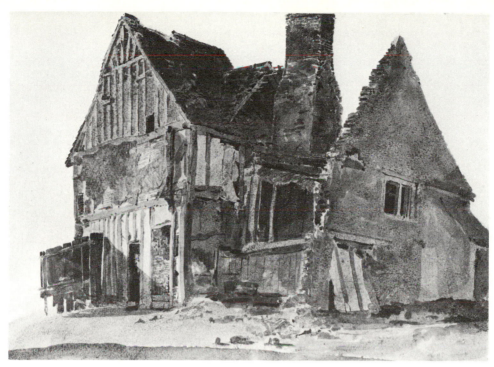

Cat. no. 20

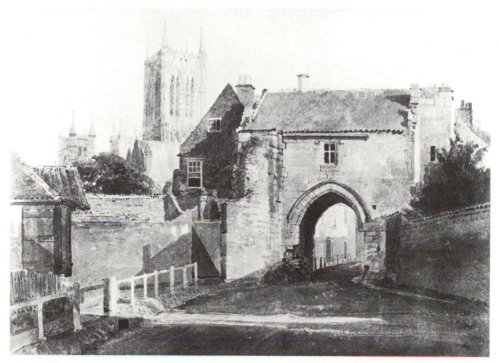

Cat. no. 21

Cat. no. 22

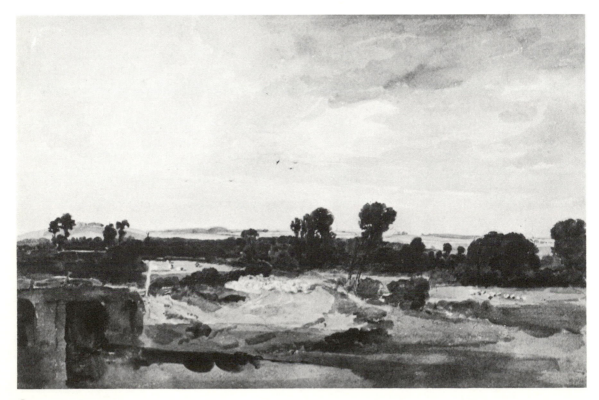

Cat. no. 23

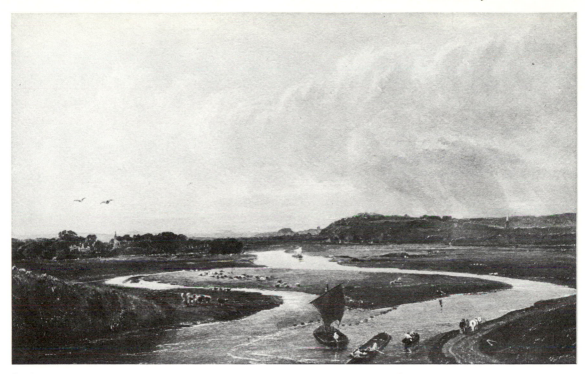

Cat. no. 24

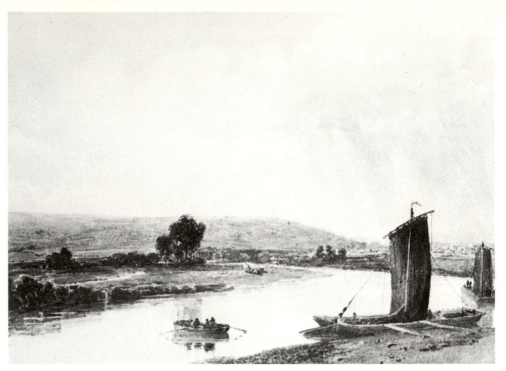

Cat. no. 25

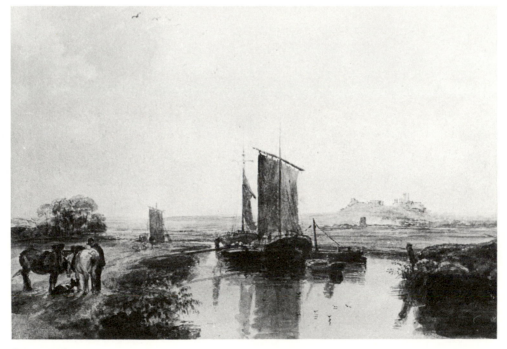

Cat. no. 26

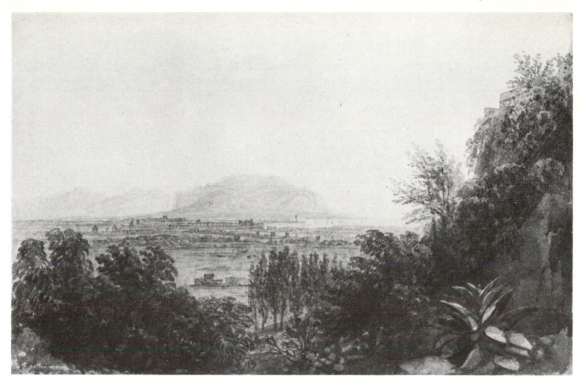

Cat. no. 27

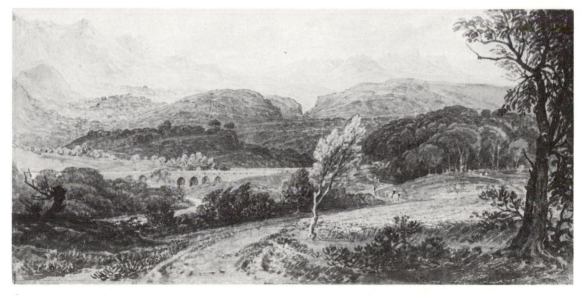

Cat. no. 28

Cat. no. 29: *see* Colour plate II

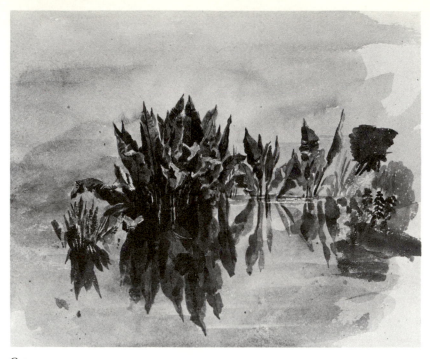

Cat. no. 30

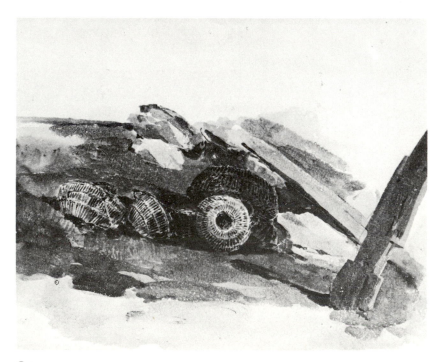

Cat. no. 31

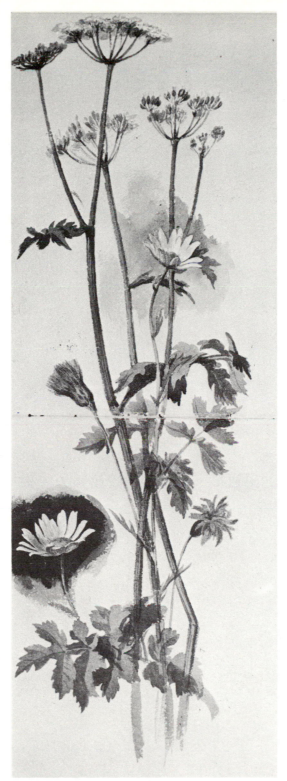

Cat. no. 32

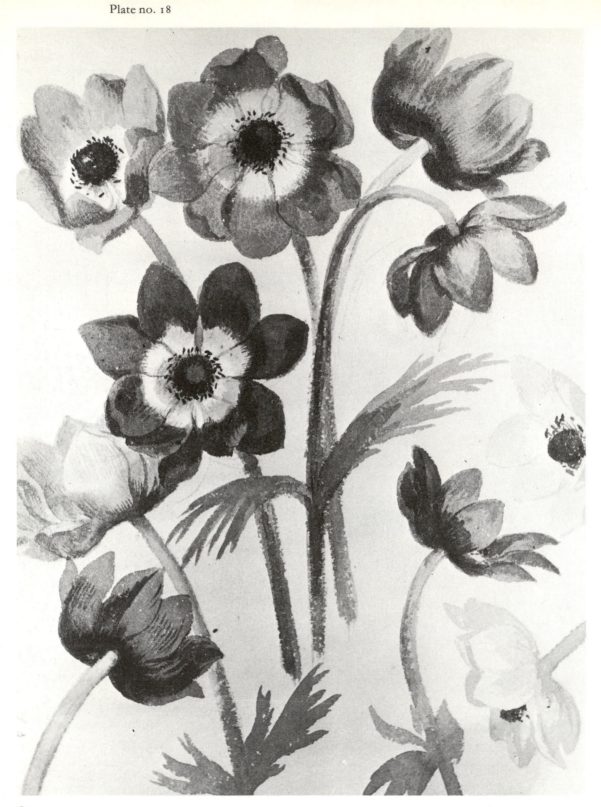

Cat. no. 33

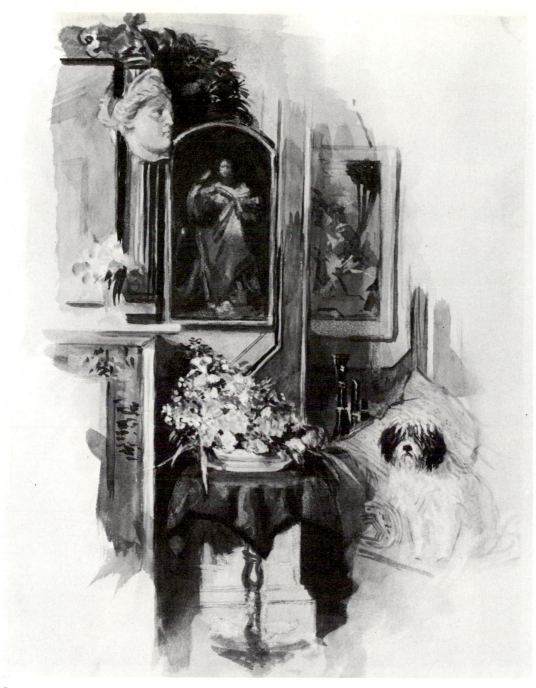

Cat. no. 34

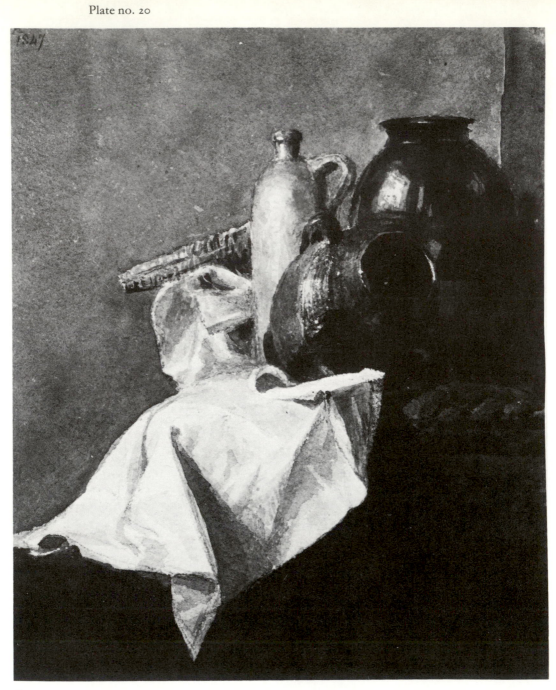

Cat. no. 35

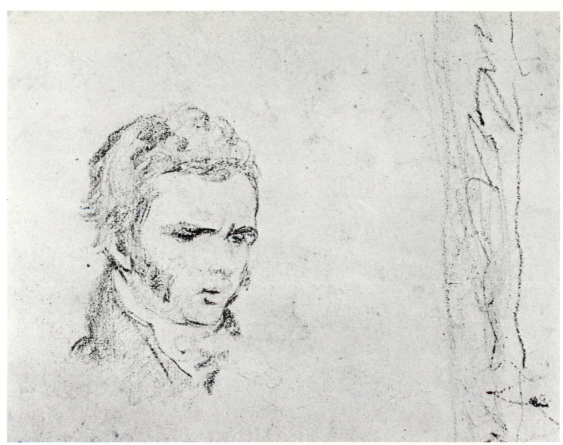

Cat. no. 36

Cat. no. 37

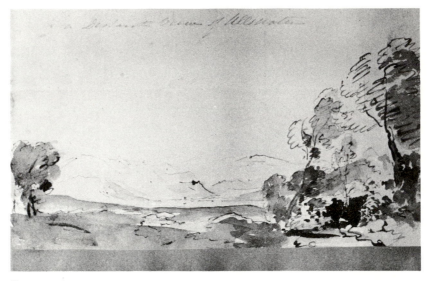

Cat. no. 38

Cat. no. 38

Cat. no. 39

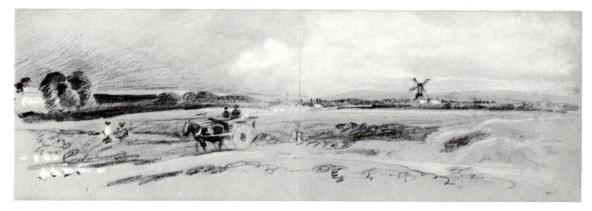

Cat. no. 40

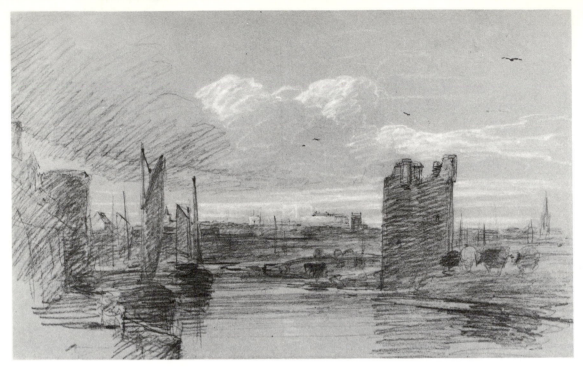

Cat. no. 41

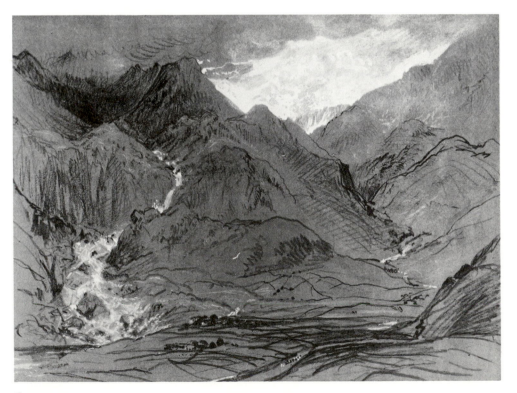

Cat. no. 42

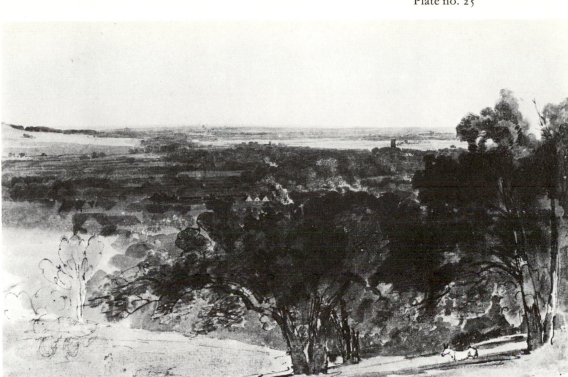

Cat. no. 43

Plate no. 26

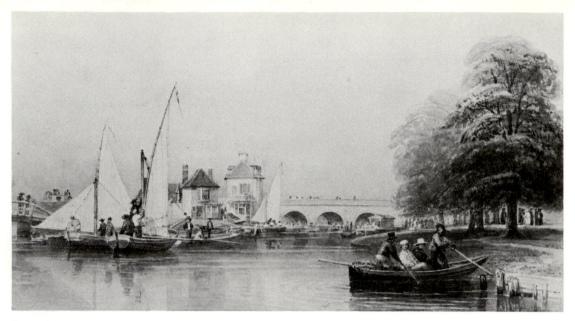

Cat. no. 44

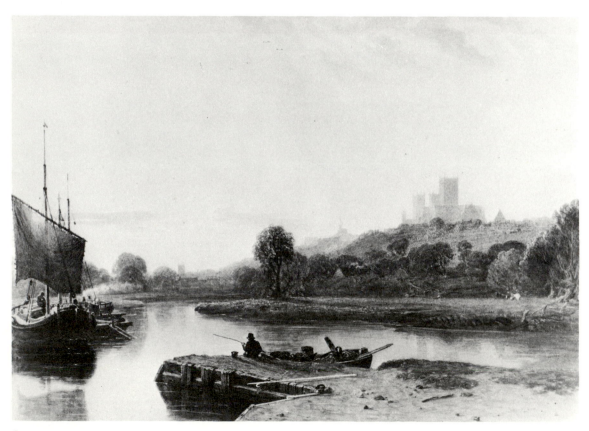

Cat. no. 45

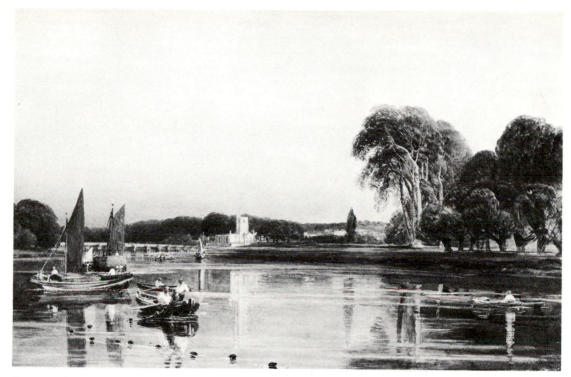

Cat. no. 46

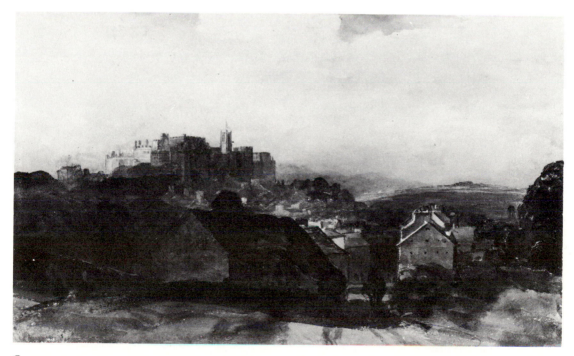

Cat. no. 47 Cat. no. 48 : *see* Colour plate III

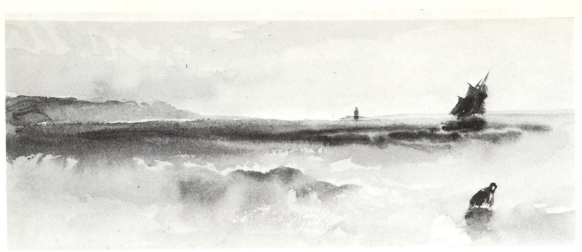

Cat. no. 49

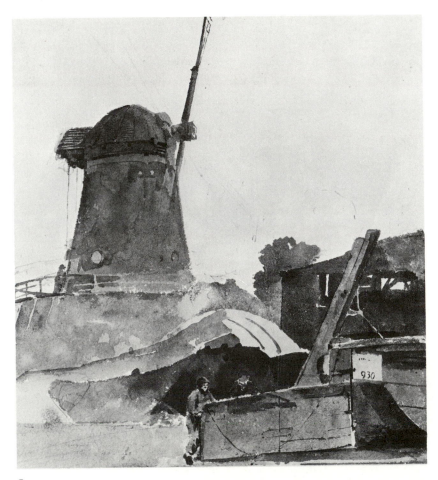

Cat. no. 50

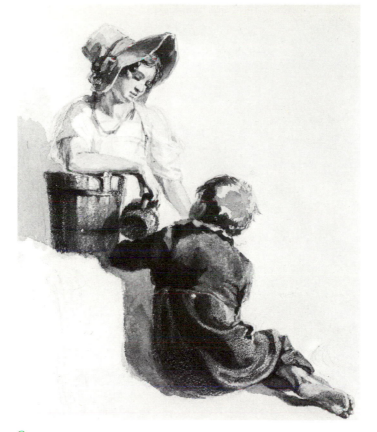

Cat. no. 51

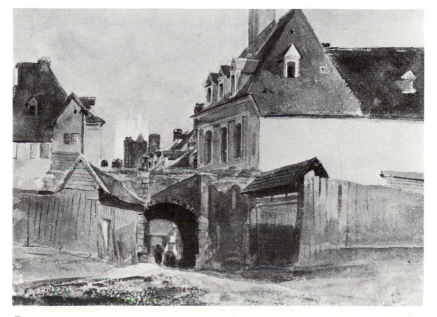

Cat. no. 52

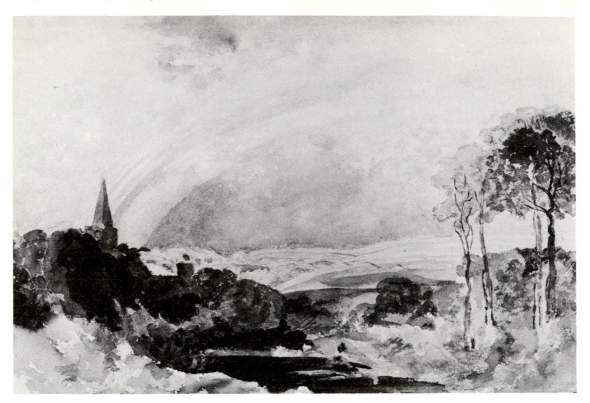

Cat. no. 53

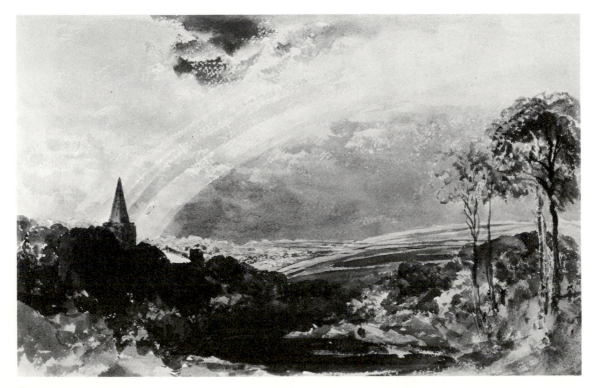

Cat. no. 54

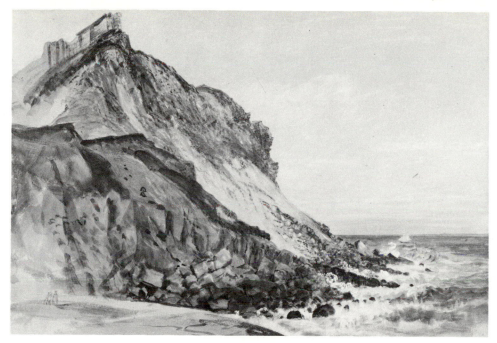

Cat. no. 55

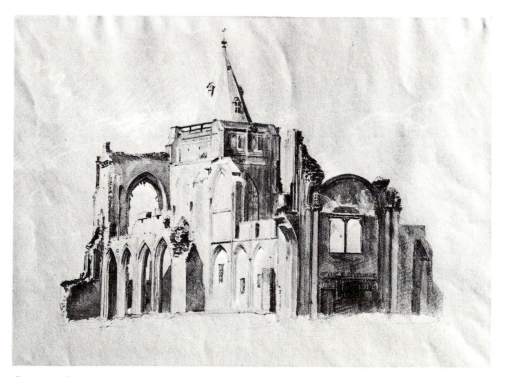

Cat. no. 56

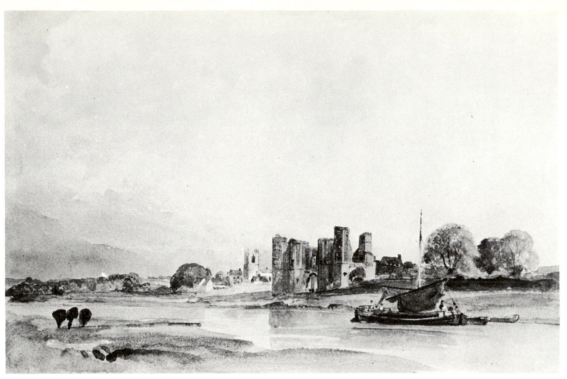

Cat. no. 57

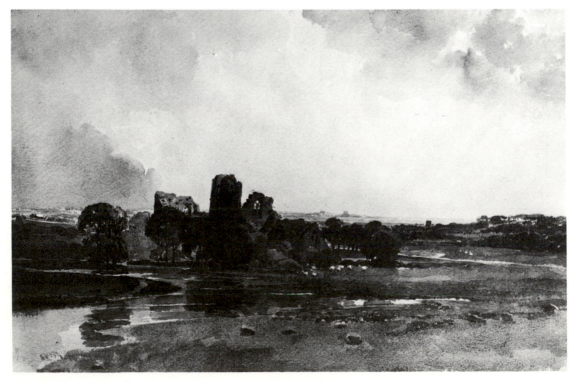

Cat. no. 58

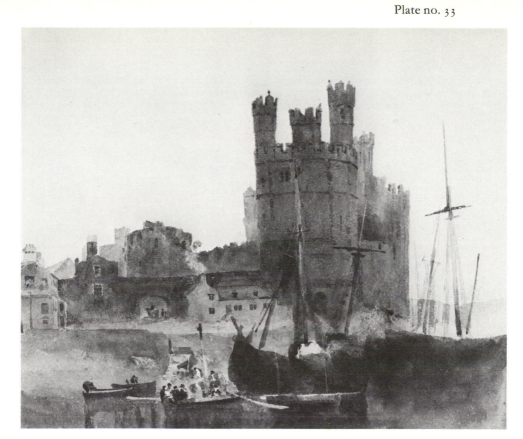

Cat. no. 59

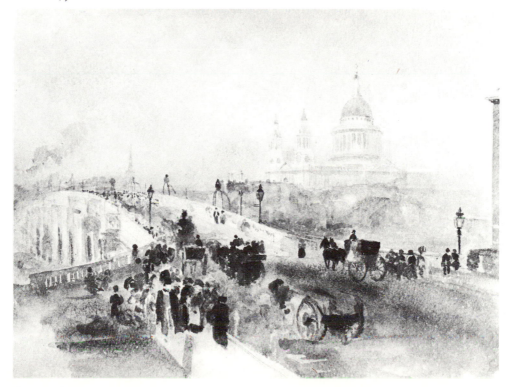

Cat. no. 60

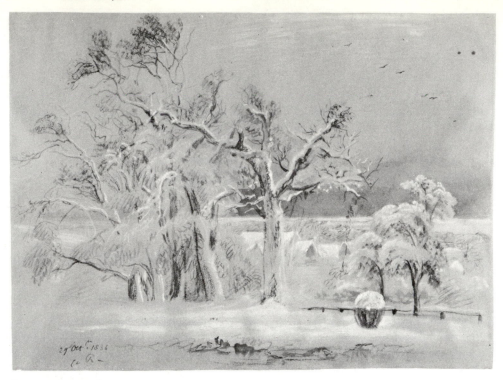

Cat. no. 61

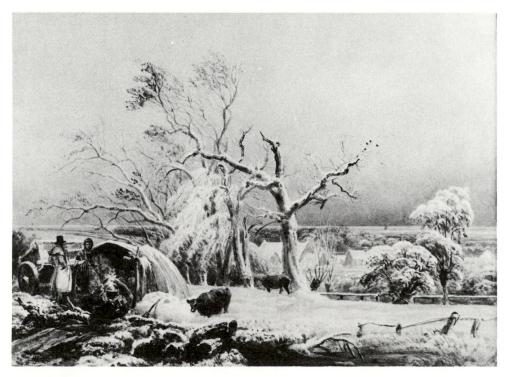

Cat. no. 62

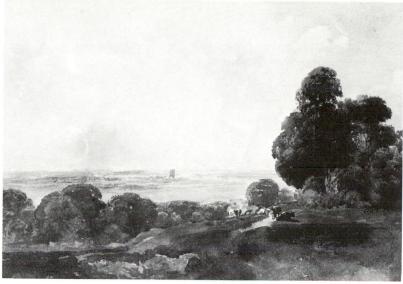

Cat. no. 63

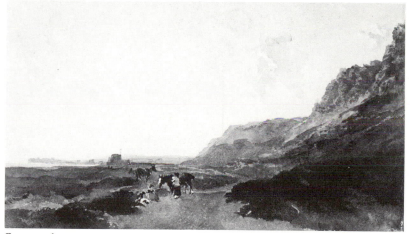

Cat. no. 64

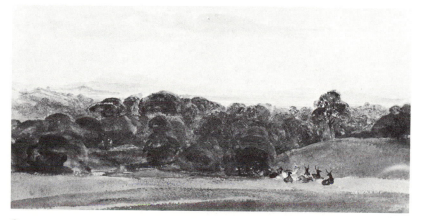

Cat. no. 65

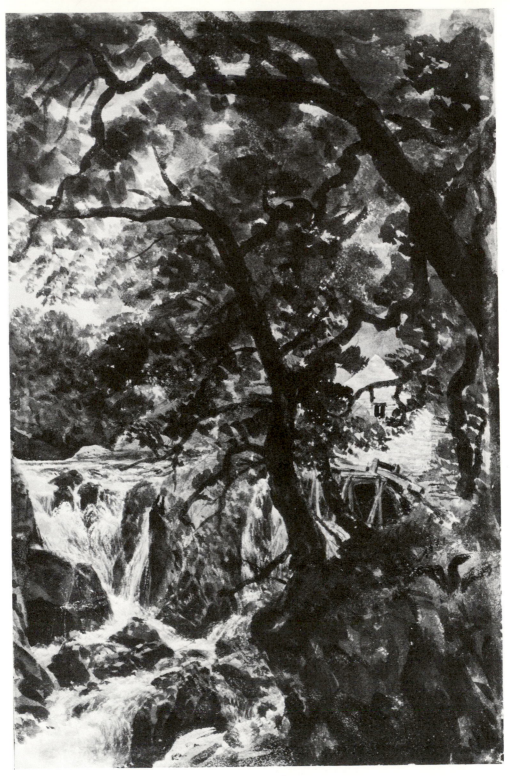

Cat. no. 66

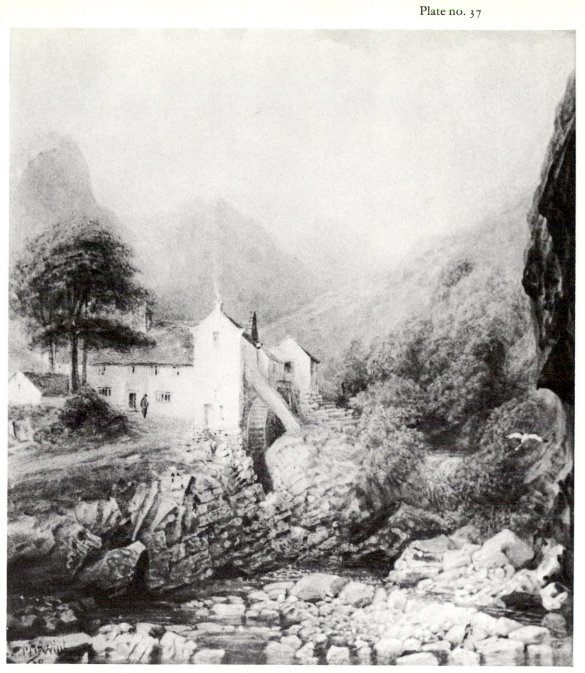

Cat. no. 67

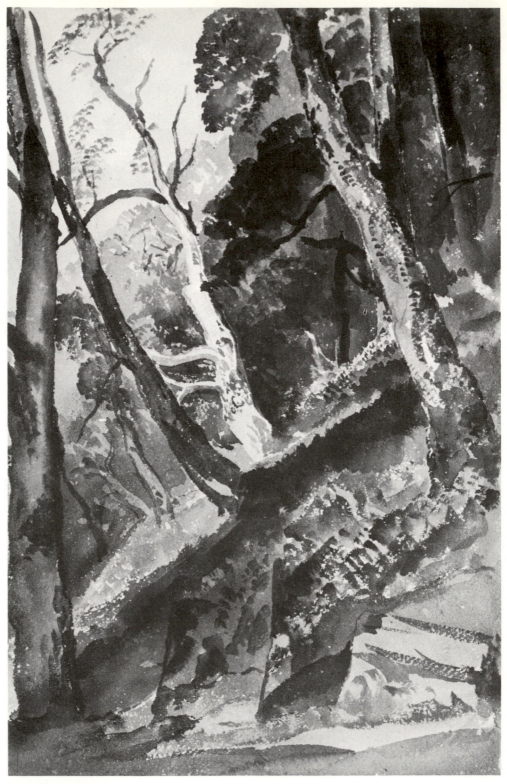

Cat. no. 68

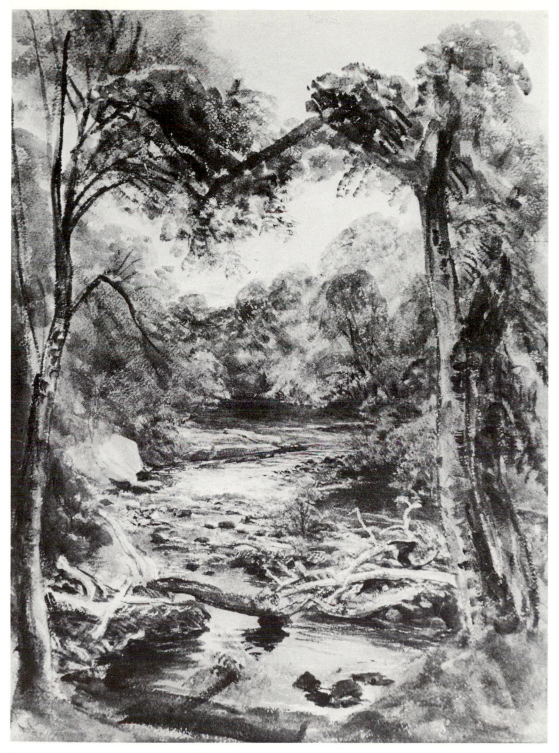

Cat. no. 69

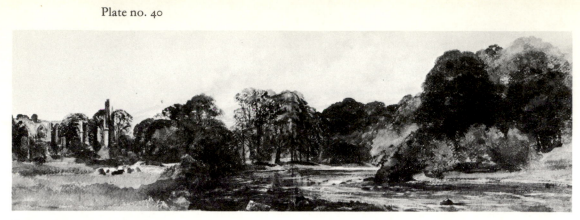

Cat. no. 70

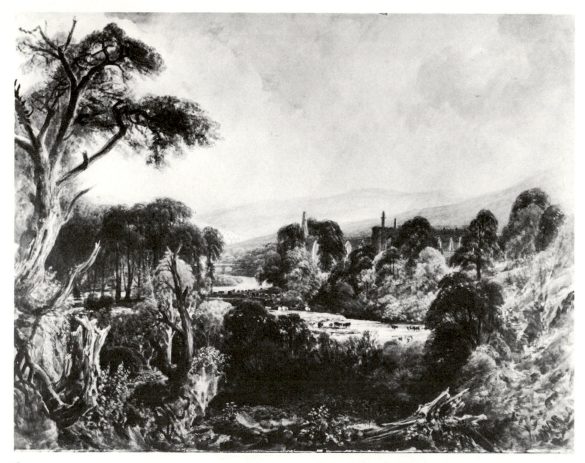

Cat. no. 71

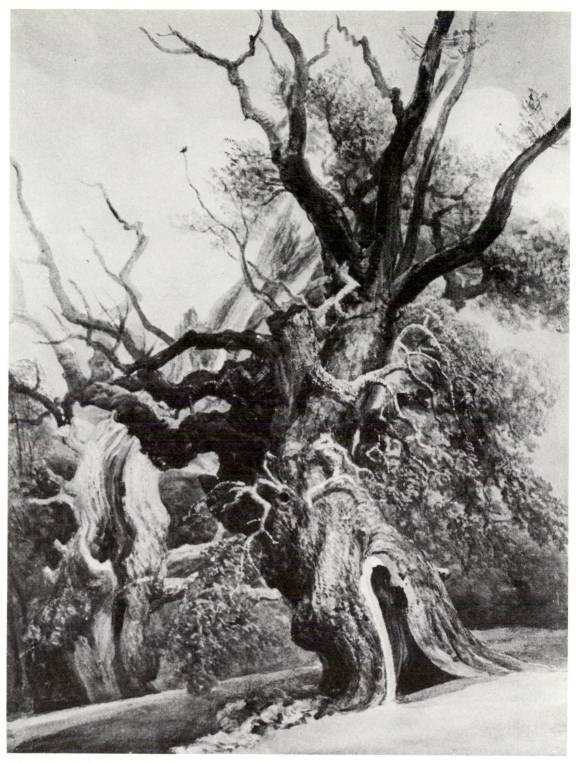

Cat. no. 72

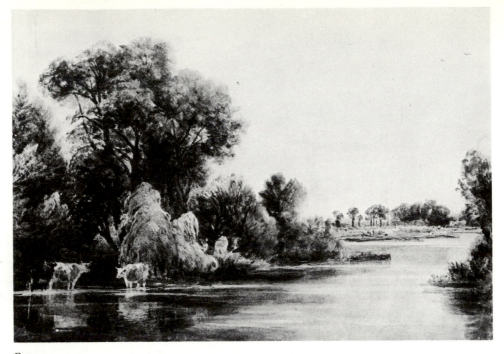

Cat. no. 73

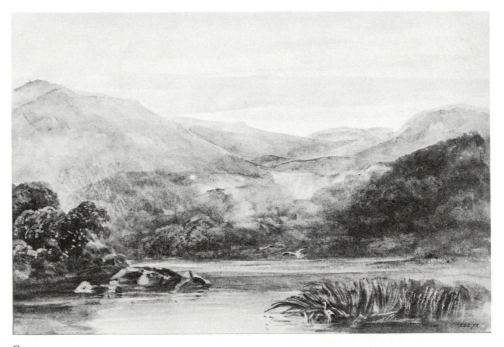

Cat. no. 74

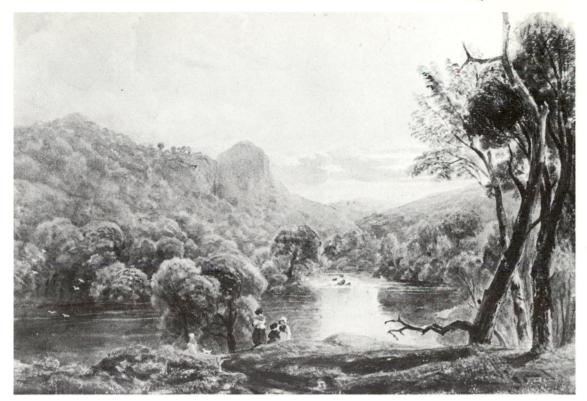

Cat. no. 75

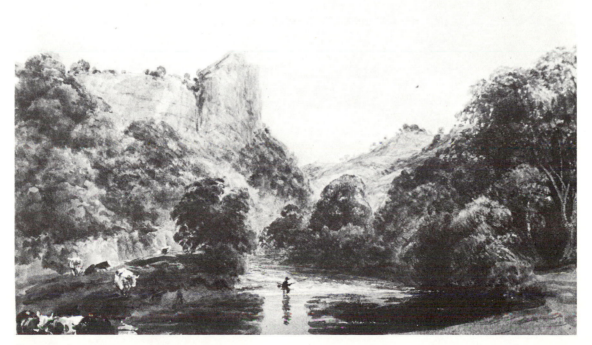

Cat. no. 76

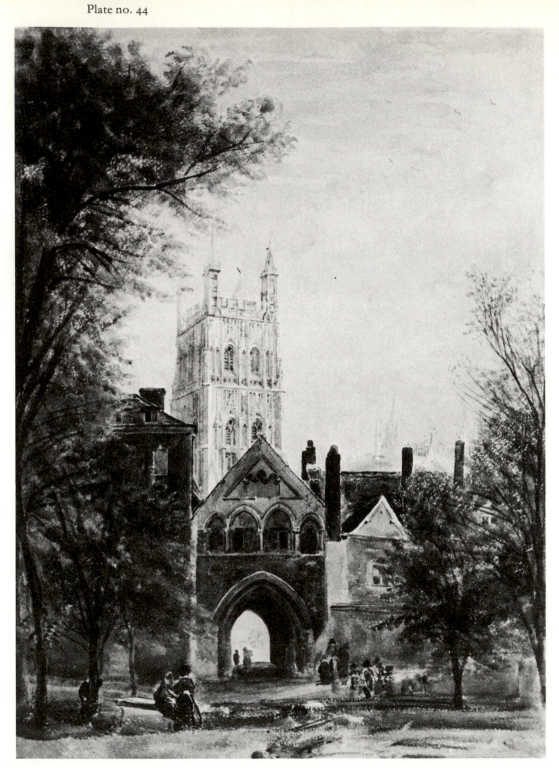

Cat. no. 77

Cat. no. 78

Plate no. 46

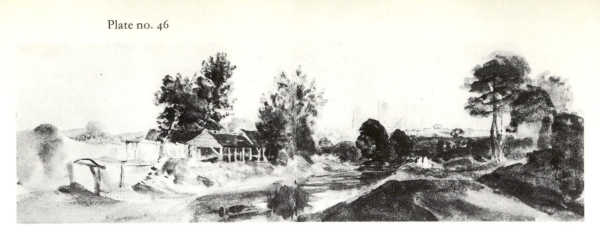

Cat. no. 79

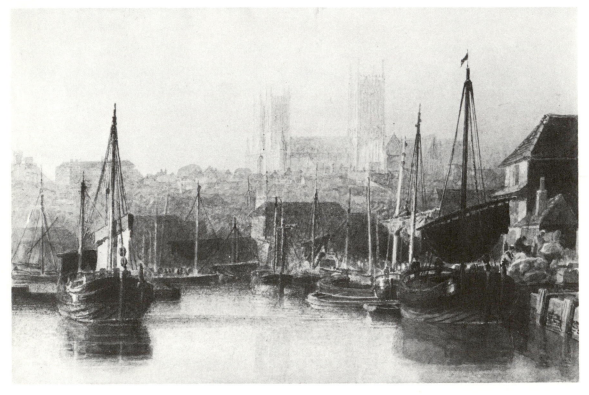

Cat. no. 80

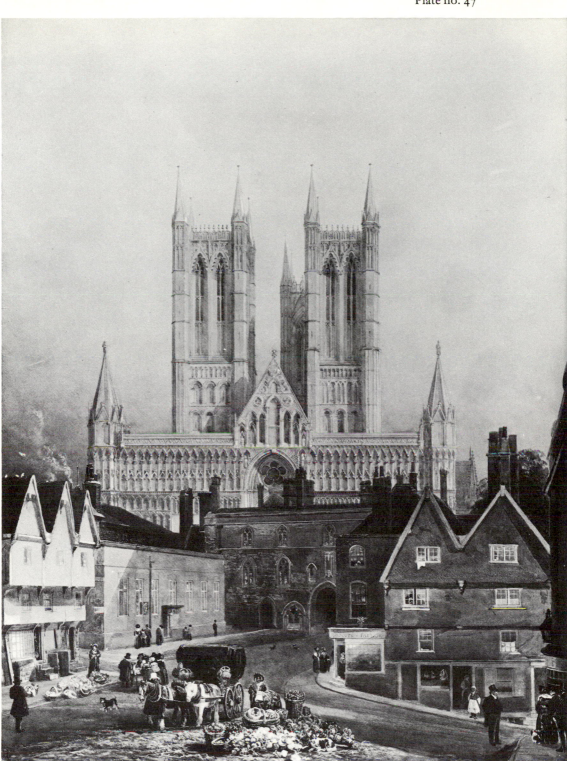

Cat. no. 81

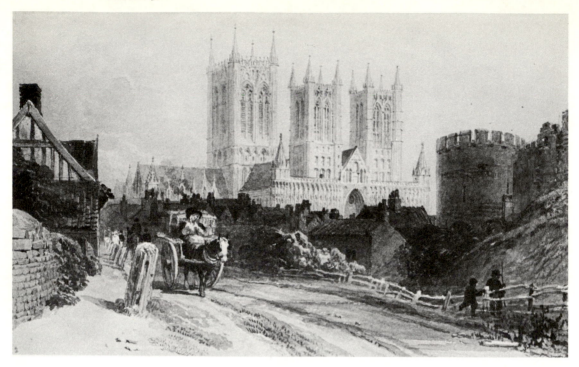

Cat. no. 82

Cat. no. 83

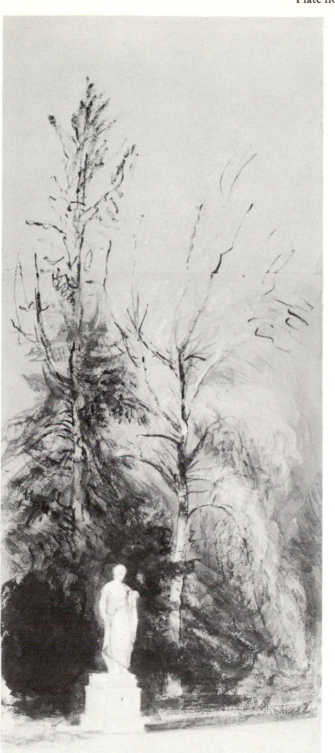

Cat. no. 84

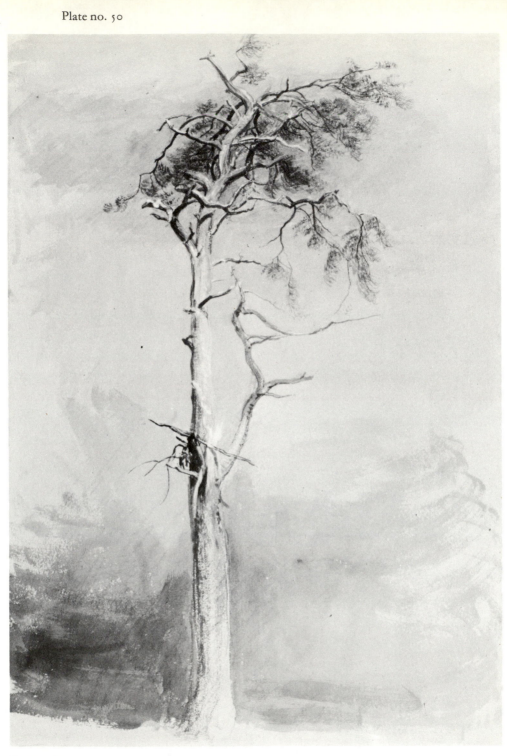

Cat. no. 85

Cat. no. 86

Cat. no. 87

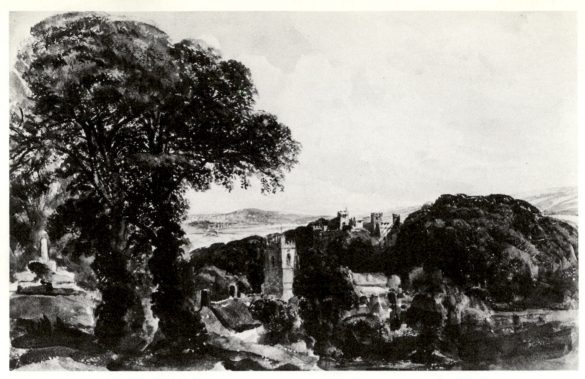

Cat. no. 88

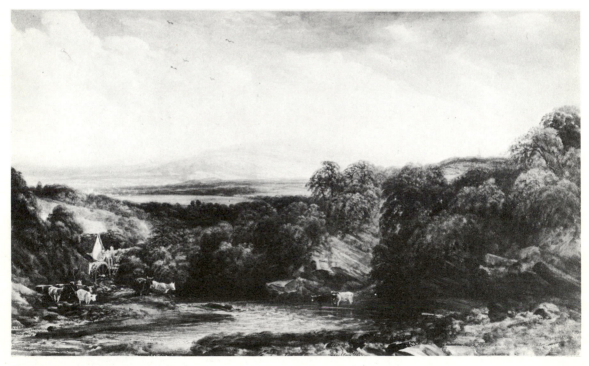

Cat. no. 89

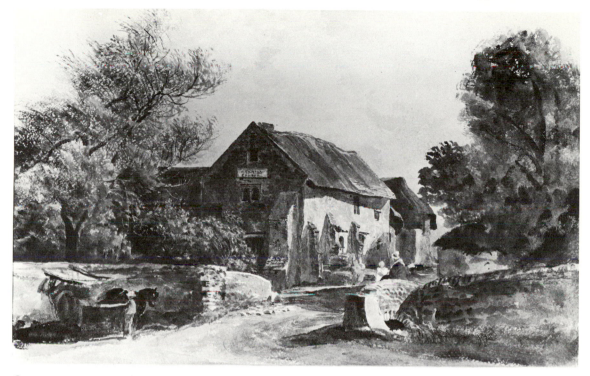

Cat. no. 90

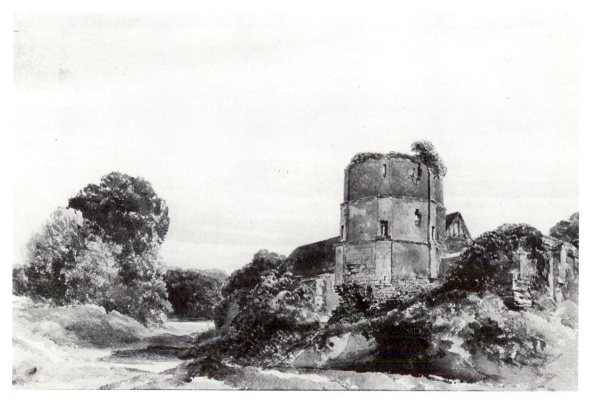

Cat. no. 91

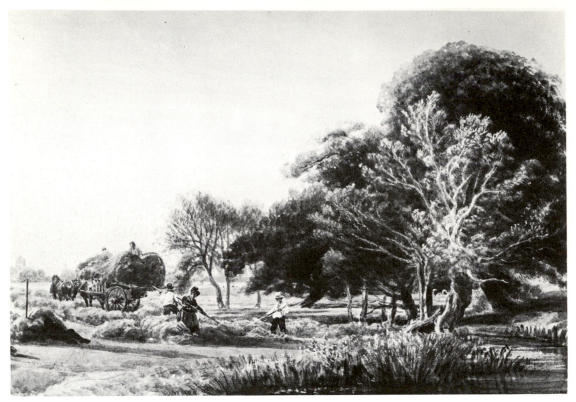

Cat. no. 92

Cat. no. 93

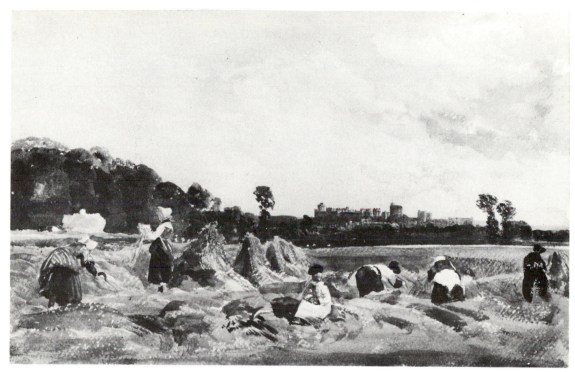

Cat. no. 94

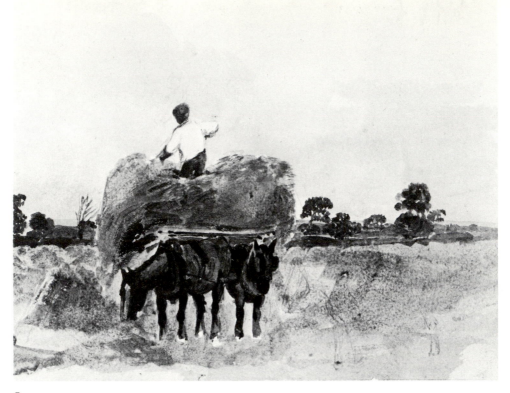

Cat. no. 95

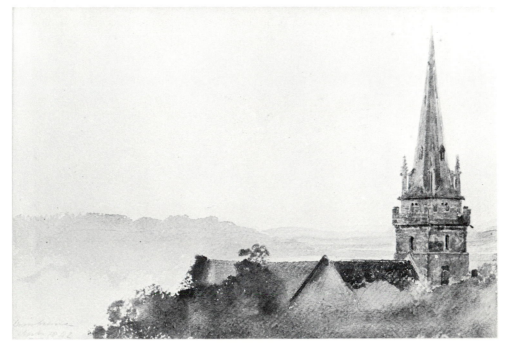

Cat. no. 97

Cat. no. 96: *see* Colour plate IV
Cat. no. 98: *see* Colour plate V
Cat. no. 99: *see* Colour plate VI

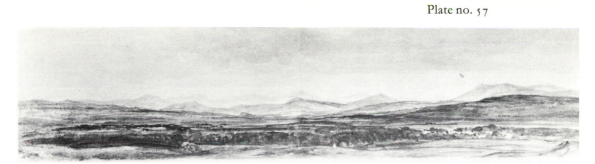

Cat. no. 100

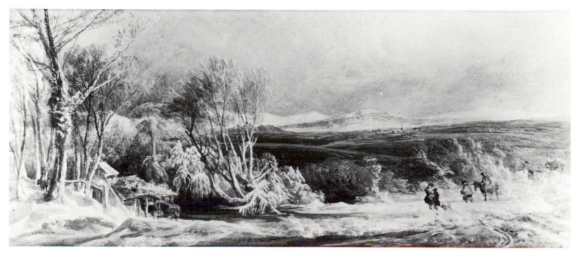

Cat. no. 101

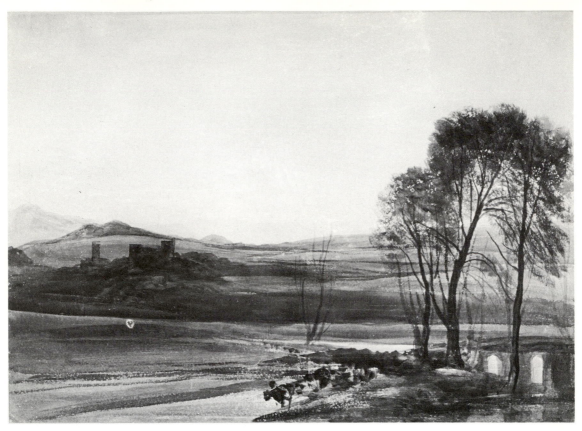

Cat. no. 102

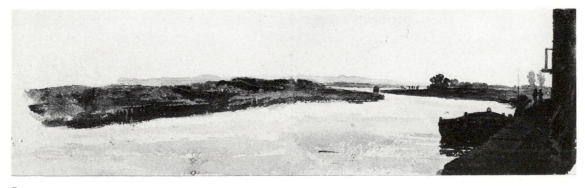

Cat. no. 103

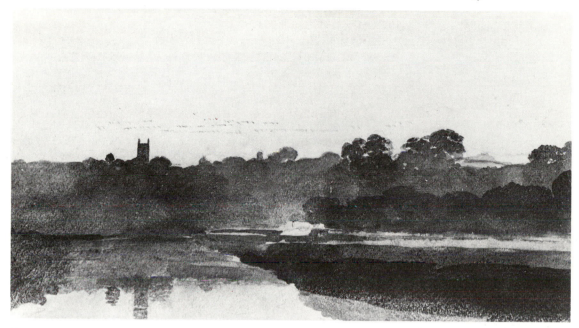

Cat. no. 104

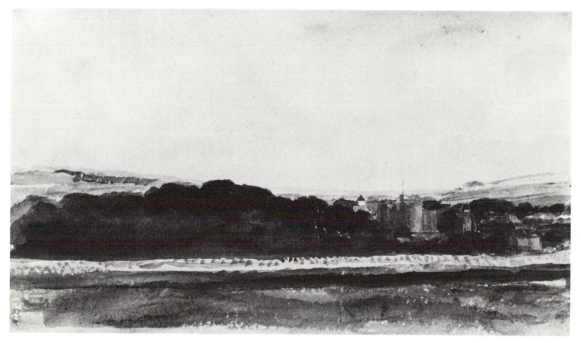

Cat. no. 105

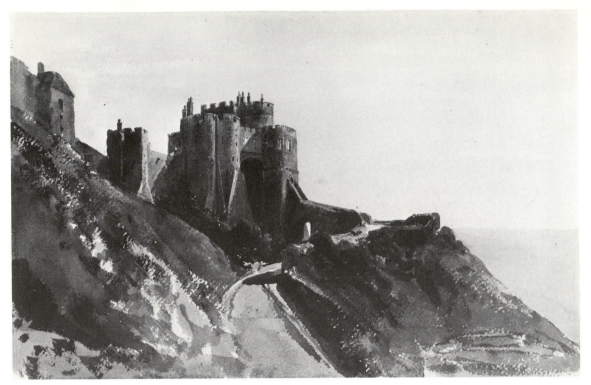

Cat. no. 106

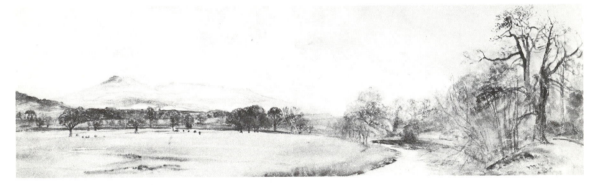

Cat. no. 107

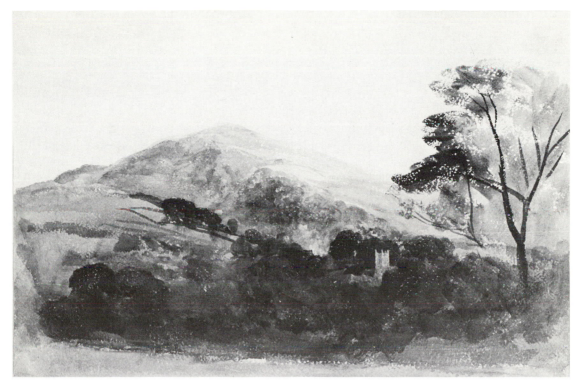

Cat. no. 108

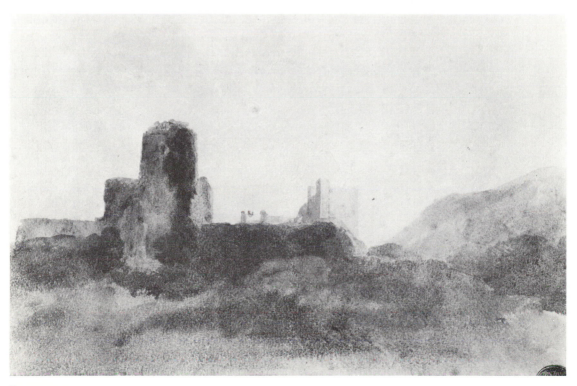

Cat. no. 109

Cat. no. 110

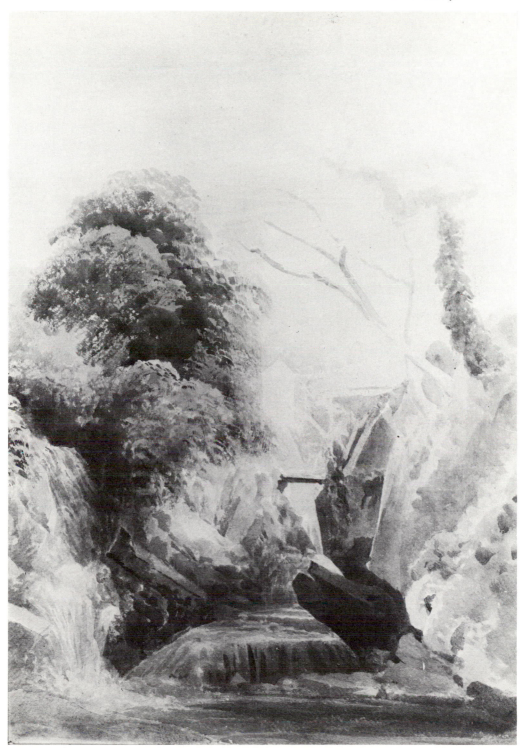

Cat. no. 111

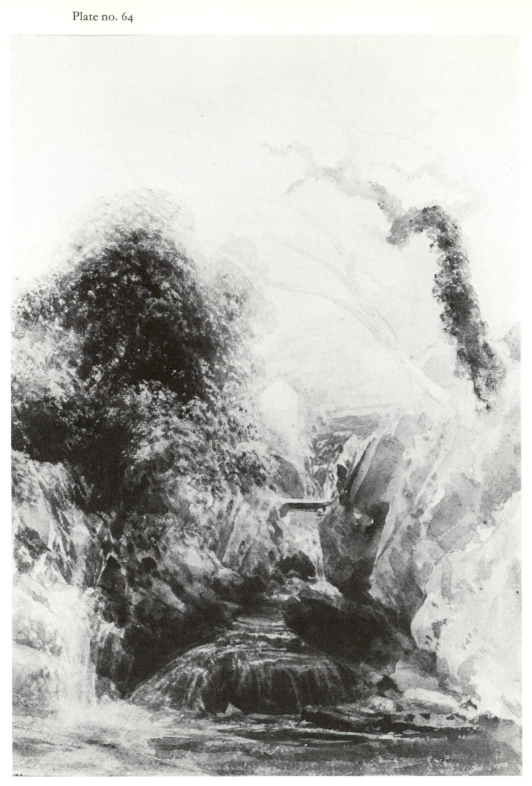

Cat. no. 112

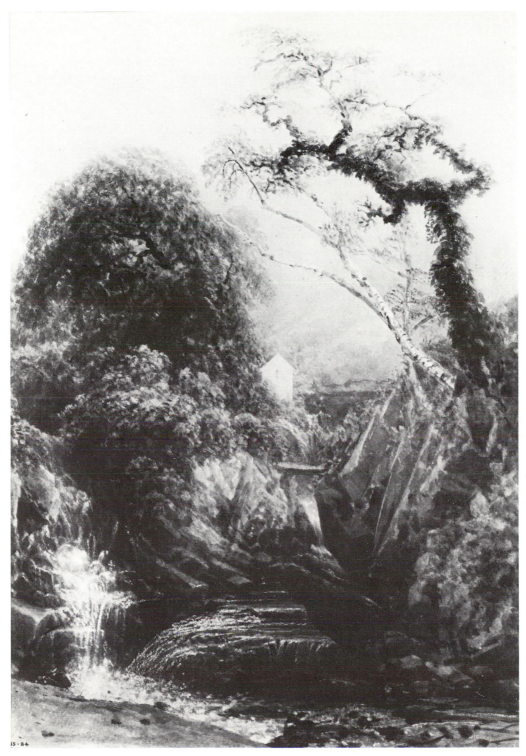

Cat. no. 113

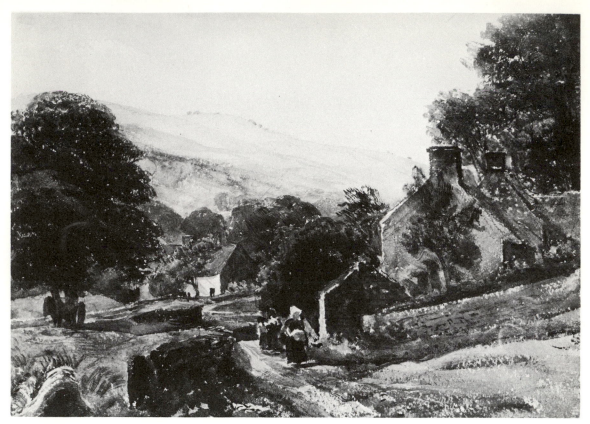

Cat. no. 114

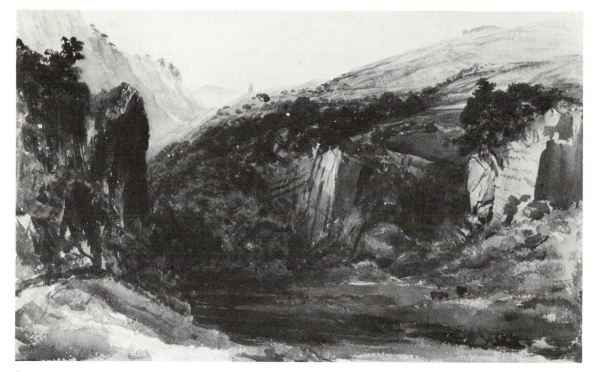

Cat. no. 115

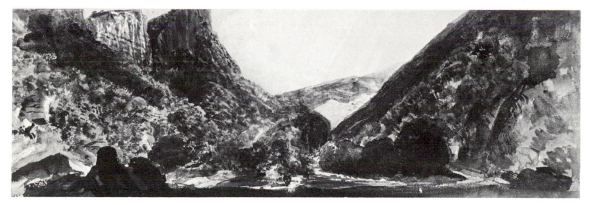

Cat. no. 116

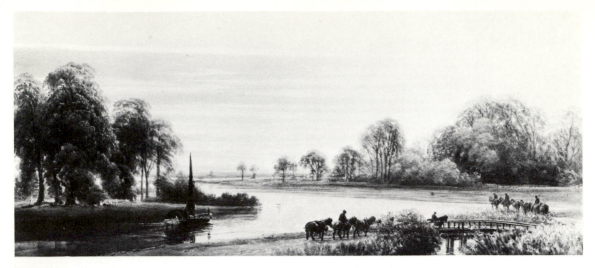

Cat. no. 117

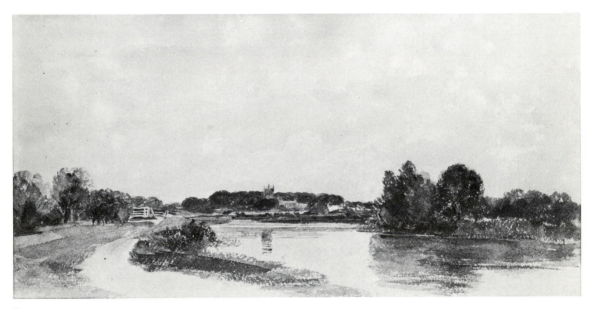

Cat. no. 118

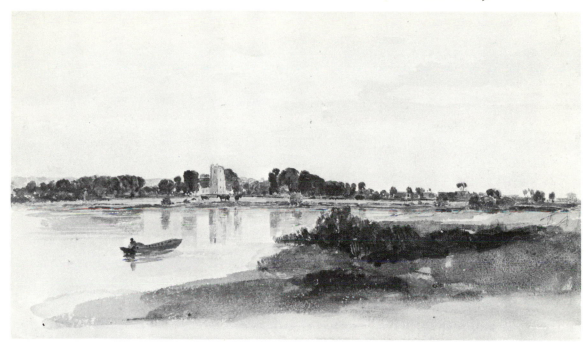

Cat. no. 119

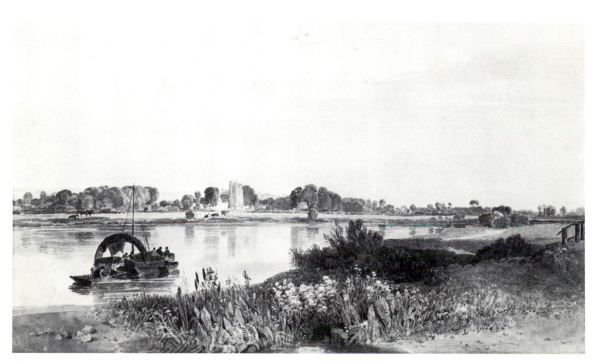

Cat. no. 120

Plate no. 70

Cat. no. 121

Cat. no. 122

Cat. no. 123 : *see* Colour plate VII
Cat. no. 124 : *see* Colour plate VIII

Plate I

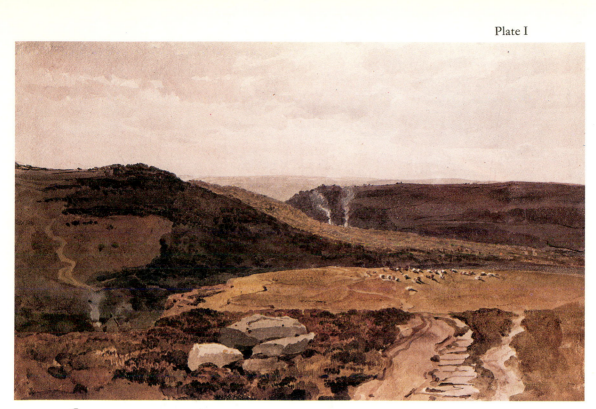

Cat. no. 11

Plate II

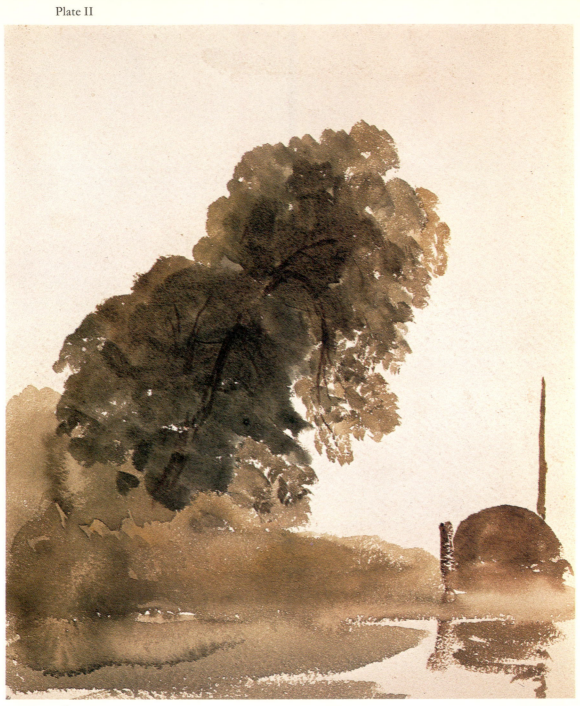

Cat. no. 29

Plate III

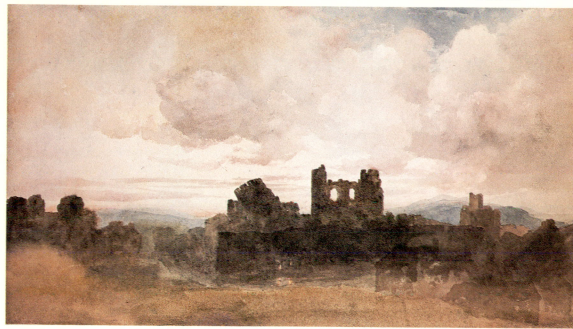

Cat. no. 48

Plate IV

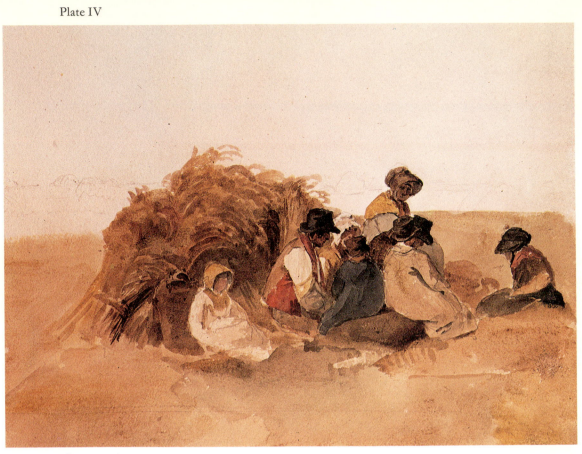

Cat. no. 96

Plate V

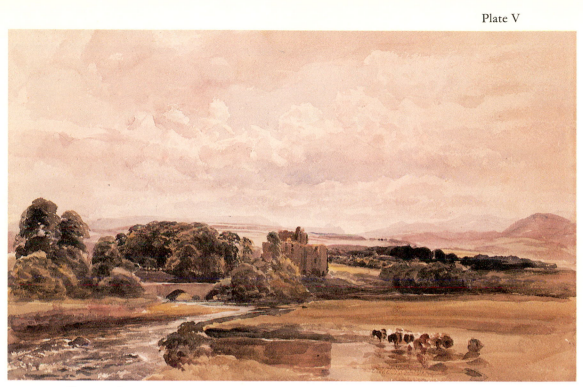

Cat. no. 98

Plate VI

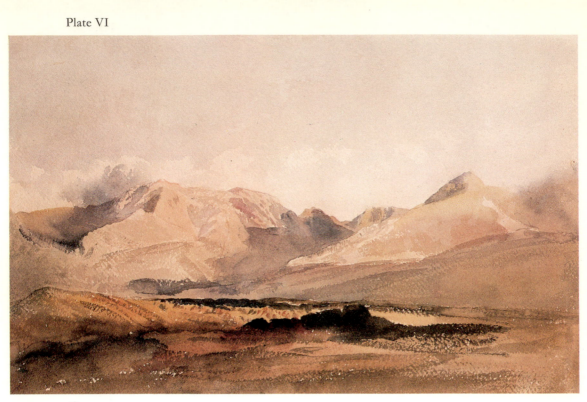

Cat. no. 99

Plate VII

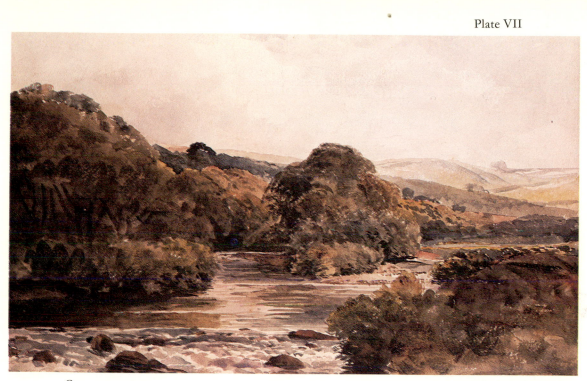

Cat. no. 124

Plate VIII

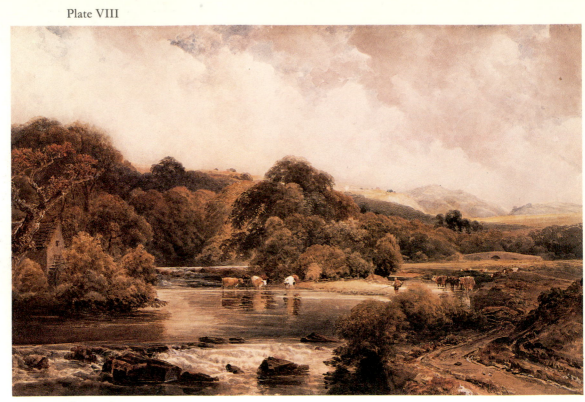

Cat. no. 123